MOM'S
LITTLE BOOK OF
DISPLAYING
CHILDREN'S ART

Lisa Bearnson

with

Julie Taboh

CREATING KEEPSAKES BOOKS
Orem, Utah

Copyright © 2000 Porch Swing Publishing, Inc., and Blackberry Press, Inc. All rights reserved. No part of this book may be reproduced or transmitted in any manner whatsoever without written permission from the publisher.

Published in 2000 by Creating Keepsakes Books, a division of Porch Swing Publishing, Inc., 354 South Mountain Way Drive, Orem, Utah 84058, 800/815-3538. Visit us at www.creatingkeepsakes.com.

PRINTED IN THE U.S.A.

Library of Congress Cataloging-in-Publication Data

Bearnson, Lisa.
 Mom's little book of displaying children's art / by Lisa Bearnson with Julie Taboh.
 p. cm. — (Mom's little book of—)
 ISBN 1-929180-16-0 (alk. paper)
 1. Children's art. 2. Art—Exhibition techniques. I. Taboh, Julie. II. Title. III. Series
 N352.B425 2000
 704'.054—dc21 00-030300

Creating Keepsakes Books may be purchased in bulk for sales promotions, premiums, or fundraisers. For information, please write to: Special Markets Department, Creating Keepsakes Books, 354 South Mountain Way Drive, Orem, Utah 84058.

Thank you to Sharon Negri and the Hill Preschool for letting us paint and wallpaper frames for an art gallery on a wall of the school. And special thanks to the following children whose art appears on the wall (see pages 26 and 27): Top row, left to right: Catherine Ragonese, Ryan Muzzio, Enti Mooskin, Catherine Ragonese, Hannah S. Bernhardt, Aleson Laird. Middle row, left to right: Elizabeth Lowery, Nicholas Byron Escobar, Ian Curran. Bottom row, left to right: Alistair J. Andrulis, John Michael Tanner, Cassie Hart, Benjamin Graney Green.

Creating Keepsakes Books
Editorial Office, Washington, D.C.
Director: Maureen Graney/Blackberry Press, Inc.
Art Director: Susi Oberhelman
Production Consultant: Kathy Rosenbloom
Editorial/Research Assistant: Courtney McGowan
Editors: Christine Hauser, Charles D. Anderson
Index: Pat Woodruff

Archival consultants: Jeanne English and Al Thelin, Preservation Conservation Alliance, Salt Lake City, Utah.

Principal Photography:
Renée Comet Photography, Washington, D.C.

Cover Photo:
Michael Schoenfeld, Salt Lake City, Utah.

Photos on pages 26 and 27:
Frank Lavelle, Annandale, Virginia.

Creating Keepsakes™ scrapbook magazine
Main Office, Orem, Utah
Editorial Director: Lisa Bearnson
Creative Director: Don Lambson
Publisher and CEO: Mark Seastrand

Creating Keepsakes™ scrapbook magazine is published ten times a year. To subscribe, call 888/247-5282.

Got Tips? We'd love to hear from you! If you've got great "mom" ideas that you'd like to share with other moms, write to us and maybe we'll use them in a future publication. All submissions become the property of Creating Keepsakes and cannot be returned. Due to the volume of mail, personal responses are not possible. Write to: Creating Keepsakes Books, a division of Porch Swing Publishing, Inc., 354 South Mountain Way Drive, Orem Utah 84058. Website: www.creatingkeepsakes.com

BEYOND THE

INTRODUCTION

REFRIGERATOR

Did you know that the average American child brings home two to three pieces of artwork weekly from school? This means a child between the ages of two and twelve makes close to 1,200 creations (that's right—1,200!) Your little Picasso is proud of his or her art and you want to boost your child's self-esteem, so you tape the art to an already cluttered fridge. When a piece of artwork finally falls to the floor, you tell yourself, "I can't keep everything," then you stash it—with a sense of guilt—in a bag in the bottom of the trash. You pray that your little dear won't find it.

If you have kids and this scenario sounds familiar, this book's for you! While it's true that you can't save everything, the fun ideas on the following pages will encourage you to dig that precious artwork out of the trash and off those dusty shelves. We'll show you how to showcase them in innovative ways throughout your home.

Remember this advice when deciding what to keep or toss:

- If the creation showcases original artwork, it's a keeper.
- You should keep self-portraits or drawings of the family.
- Toss dot-to-dots and other premade materials unless your child has done an exceptional coloring job.
- Take pictures of large three-dimensional items, then toss the hard-to-save originals.
- Keep anything that supplies facts about the child at that time (such as weight or height).
- Keep handwriting and test samples.

Enjoy the process! I had a ball creating the dowel on the front cover with my children. I guarantee that when our kids are all grown up, these pieces of artwork will continue to decorate our homes and become invaluable keepsakes.

—LISA BEARNSON

CONTENTS

MATTING FRAMING
ON THE WALL
DISPLAYING

6

Tip #1 Portfolios for
Organizing 8

Tip #2 Choosing Store-
Bought Frames 9

Tip #3 Mat Boards as
Instant Frames 10

Tip #4 Plexiglas Frames 11

Tip #5 Frames for Desktops 12

Tip #6 Simple Foam Core
Backing 13

Tip #7 Three-Tier Wall
Hanging 14

Tip #8 Sheet Protector
Display 15

Tip #9 Mobiles and Collages 16

Tip #10 Clipboard Frames 17

Tip #11 Craft Stick Frames 18

Tip #12 Frames from
Unusual Objects 19

Tip #13 Professional Framing 20

Tip #14 Celebrating Scribbles 21

Tip #15 The Story behind
the Picture 22

Tip #16 Twine-and-Clothespin
Display 23

Tip #17 Stuffed Animal Chain 24

Tip #18 Dowel Display 25

Tip #19 Art Gallery Frames:
Wallies 26

Tip #20 Art Gallery Frames:
Stamps 27

SAVING AND
SCRAPBOOKS AND BEYOND
PRESERVING ART

28

Tip #21 Mini Scrapbooks 30

Tip #22 Accordion Books 31

Tip #23 Framing Art for
Your Scrapbook 32

Tip #24 A Portrait with
the Picture 33

Tip #25 The Next Picasso 34

Tip #26 Profiling the Artist 35

Tip #27 Foolproof
School Pages 36

Tip #28 Scrapbook Art Gallery 37

Tip #29 Showcasing 3-D Art 38

Tip #30 Showing All the
Variations 39

Tip #31 A Rotating Wheel
for Art 40

Tip #32 Cutout Enhancements 41

Tip #33 Bring a Sketch to Life 42

Tip #34 Enhancing the
Artwork 43

Tip #35 Focus on Favorites 44

Tip #36 Art as Background
Paper 45

Tip #37 Handwriting is
Art, Too! 46

Tip #38 Notes That Tell
the Story 47

GIFTS AND HOME
OFF THE WALL
DECORATING

48

Tip #39 Simple Refrigerator
Magnets 50

Tip #40 Little Refrigerator
Frames 51

Tip #41 Refrigerator Collage 52

Tip #42 Big Refrigerator
Frames 53

Tip #43 Hooks and Clips
for the Fridge 54

Tip #44 Napkin Ring and
Place Card 55

Tip #45 Tray 56

Tip #46 Plates 57

Tip #47 Key Chains 58

Tip #48 Computer Mouse Pad 59

Tip #49 Pencil Holders 60

Tip #50 Clock 61

Tip #51 Memory Game 62

Tip #52 Jigsaw Puzzle 63

Tip #53 Sweatshirt 64

Tip #54 Baby T-Shirts 65

Tip #55 Apron 66

Tip #56 Quilt 67

CARDS GIFT TAGS
STATIONERY
INVITATIONS

68

Tip #57 Favorite Scrapbook
Techniques 70

Tip #58 Photos and Existing
Stationery 71

Tip #59 Cards and Their
Messages 72

Tip #60 Photo Frame Cards 73

Tip #61 A Set of Cards 74

Tip #62 Textured Cards 75

Tip #63 Color Photocopies
of Art 76

Tip #64 Cards from
Color Printers 77

Tip #65 Announcements 78

Tip #66 Invitations 79

Tip #67 Postcards 80

Tip #68 Christmas and
Easter Gift Tags 81

Tip #69 Other Holiday
Gift Tags 82

Tip #70 Celebration Gift Tags 83

Tip #71 Gift Wrapping 84

Tip #72 Stationery 85

Tip #73 Memo Pads 86

Tip #74 Bookmarks 87

Tip #75 Calendars 88

Resources 89

Index 93

Whether it's a doodle on a napkin or a painting rich with detail, nothing seems to add more credibility to a piece of art than a frame. Whether you want quick-framing ideas or archival-quality preservation for the art your children produce, there are many creative options that will beautify your home and reinforce the kids' self-esteem.

Matting Basics

Matting serves two purposes: to set off artwork visually and to separate art from the frame's glass, allowing it to breathe. Consider the following when choosing a mat.

■ Make sure the mat is acid-free so that acid and lignin from the paper don't ruin the art. Acid-free mat boards come in a variety of grades. Bainbridge Alpharag and Crescent mats are two brands of high-quality mats that can be found at craft or framing stores.

■ Choose a color that does not distract from the artwork.

■ Use brightly colored double or even multiple matting when you want to emphasize a series of colors from a particularly vibrant piece of art, or when you want to display three-dimensional art without using a shadow box.

Framing Basics

■ When you're having your children's art professionally framed, make sure the framer uses acid-free materials every step of the way, since even something as benign as cardboard backing will, if it's not acid-free, allow acid migration to a piece of art.

■ Metal frames are good options, since they have no acid content and often come in a variety of colors. Wood frames are a good choice if the inside edge (called the rabbit) is sealed with urethane or shellac to protect art from the natural acids that would otherwise seep out from the wood.

■ For further preservation of valuable art from wood acid, consider applying an acrylic clear finish to the back of the frame.

■ To prevent light from fading

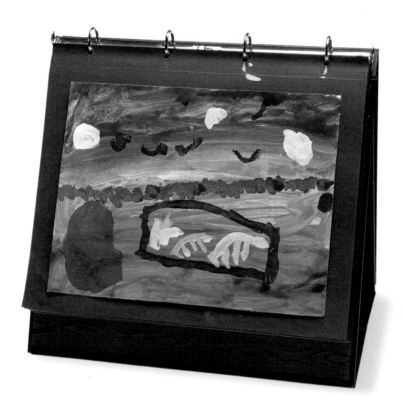

artwork, consider using a special glass or Plexiglas that filters out 85-95% of damaging UV light.

Displaying Basics

When displaying children's art, take into consideration the mood and feel of the room in which it will be displayed.

- If art is elaborate, use a simple frame. If art has a simple design, a more elaborate frame may add needed structure.
- Consider your audience. If art is going to be displayed in a child's bedroom or playroom, display it at child-eye level.
- Consider framing a series of pieces that are uniform in subject matter, material, or medium with a similar style of frame and mat.

SUPPLIES Spel-binder by Joshua Meier with Mylar sheet protectors, photo mounts, original art.

The general rule of thumb when displaying framed art is that large pieces should be displayed in large spaces while smaller works of art look better in smaller spaces.

So whether you prefer store-bought or homemade, choose materials that are exactly right for your little artist's masterpiece. Either way, you will be preserving a very special part of childhood for present and future generations to enjoy.

Portfolios for Organizing

Artist portfolios are great for storing art. For fun, personalize one for your child.

John's portfolio

SUPPLIES 20 x 26" Fiberstok portfolio, Frances Meyer and Pebbles in My Pocket paper, Me and My Big Ideas stickers, DOTS soft chalks, Anything Goes and Fill In fonts from *Best of Creative Lettering CD 1*, Toggle font from *Best of Creative Lettering CD 2* (both, Creating Keepsakes), EK Success Zig Writer pens, Zig Millennium black .08 pen, Family Treasures square punch set.

Alyssa's school days

SUPPLIES 17 x 22" Dura-Plast portfolio, Frances Meyer, Paper Patch, and Pebbles in My Pocket paper, Pencil and Simplicity fonts from *Best of Creative Lettering CD 1*, clip art from *Best of Creative Lettering CD 2* (both, Creating Keepsakes), EK Success Zig Scroll and Brush pens, Family Treasures punch art, Xyron machine, 3L photo tape.

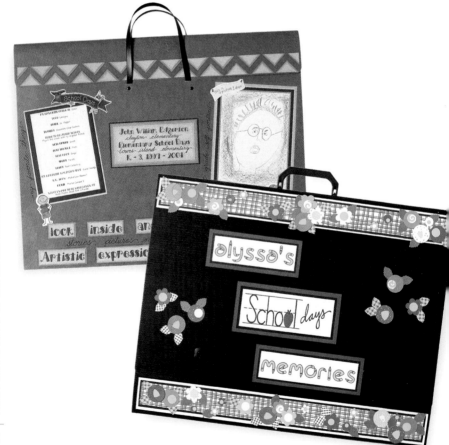

Choosing Store-Bought Frames

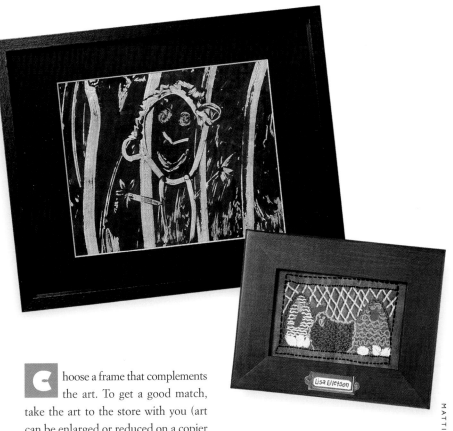

Choose a frame that complements the art. To get a good match, take the art to the store with you (art can be enlarged or reduced on a copier to fit a frame you love). Simpler frames tend to work better for art, though abstract images may be enhanced by elaborate ones. Frames decorated with little pictures or figures usually work better with photographs. The frames shown here were bought on sale at craft stores and suit the subjects well.

Black and silver
SUPPLIES Store-bought mat and frame, photo mounts, art. **INSTRUCTIONS** Mount original art to mat and insert in frame.

Wooden frame with hen
SUPPLIES Store-bought frame, white cardstock, photo of art. **INSTRUCTIONS** Mount art in frame. Hand letter artist's name and insert in nameplate.

> **IDEA TO NOTE:** Paper that looks like canvas is available for inkjet printers. Try printing scanned art out on it for a textured effect.

MATTING FRAMING DISPLAYING: ON THE WALL

Mat Boards as Instant Frames

A quick and easy way to highlight art is to slip it into a pre-cut, acid-free mat board in a color that enhances the art. To go a step further, decorate with stickers, punch art, or die cuts. Stand the frame on a store-bought easel or glue a decorative ribbon at back for wall hanging. Use copies in this type of frame to protect originals from dust or finger marks.

I love Mom and Dad
SUPPLIES Emagination Jumbo Grapevine, Jumbo Hawthorne, Jumbo White Oak punches, Zig 2-Way Glue, ribbon, photo mounts.

Makenzie
SUPPLIES Jumbo circle, swirl, small heart, flower, jumbo spiral, small circle punches (brand unknown), Zig 2-Way Glue, photo mounts.

Trout mat
SUPPLIES Frances Meyer stickers, brown Zig Writer pen, photo mounts.

INSTRUCTIONS FOR ALL Enlarge or reduce art on color copier, cropping as necessary. Secure with photo mounts and decorate.

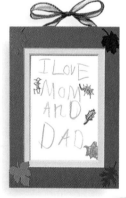

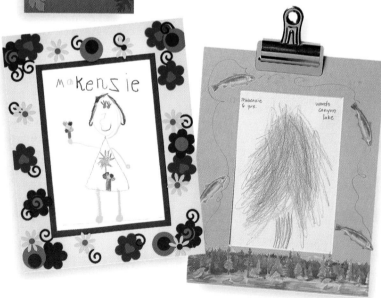

Plexiglas Frames

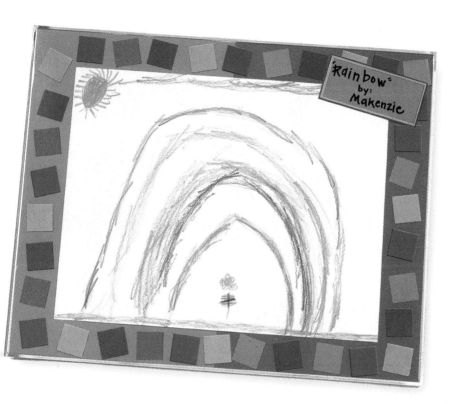

Boxy Plexiglas frames are among the easiest to use but don't really strengthen the structure of your picture the way a wooden or metal frame does. The solution: create a strong mat for the picture with acid-free papers before you slide it into the frame.

Note that the cardboard box inside the frame may not be acid-free, so add an extra layer of acid-free cardstock or low-pH tissue between the mat and the box.

SUPPLIES Plexiglas frame, assorted color cardstock including orange and red, jumbo square punch, photo mounts or other adhesive, Fiskars paper trimmer, Zig Writer black pen, art. **INSTRUCTIONS** Slightly overlap red and orange cardstock lengthwise and glue. Trim to fit exactly inside Plexiglas frame. Center and mount art on cardstock. Use jumbo square punch to make squares of colored cardstock. Create title by creating three rectangles of graduated size out of cardstock. Write title on smallest rectangle. Mount on larger rectangle, then mount on largest rectangle.

Frames for Desktops

A small framed piece of favorite children's art as part of a desktop display will brighten up anyone's office. Buy a dozen small frames on sale, photograph or photocopy several favorite masterpieces, display on your desk or give away as gifts!

The trick to working with a small frame is to make sure the art you select is a strong and clear enough image to hold up to being reduced. Abstract paintings and drawings will probably look best if displayed large, close to their original size.

Bedtime
SUPPLIES Plexiglas frame, Sonburn Blue Stars patterned paper, solid cardstock, photo mounts, pencil sketch. **INSTRUCTIONS** Copy art onto off-white cardstock on a regular copier. Trim into rectangle proportionate to frame. Trim patterned paper to fit frame. Mount art onto patterned paper and slip into Plexiglas frame.

Amber's circus
SUPPLIES Brass frame, photo of art. **INSTRUCTIONS** Crop photo to fit in frame.

IDEA TO NOTE: If you've taken a photo of a drawing and it's a little too small for the frame, simply mount on an unobtrusive shade of cardstock, leaving a narrow border.

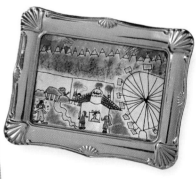

Simple Foam Core Backing

Another very simple way to frame pictures is by mounting them on foam core, which provides a light but sturdy backing. Mat the pictures first, using patterned paper or solid cardstock. The trick to working with foam core is to make sure your knife is very sharp—use a new blade! And a metal ruler works best in helping cut a straight line. Display foam core-mounted art on store-bought easels. It's best to use color copies of art for this type of framing because this method won't protect the original art from sunlight or handling.

Witch
SUPPLIES Solid and patterned paper, foam core, adhesive, color copy of artwork. **INSTRUCTIONS** Mount art on white paper and trim. Mount this on color paper. Trim to create narrow border. Mount all on patterned paper. Mount to foam core.

Three flowers
SUPPLIES White and red cardstock, foam core, adhesive, copy of art. **INSTRUCTIONS** Trim art and mount on white cardstock, leaving a narrow border. Trim and mount on red cardstock, leaving a narrow border. Mount layers on foam core.

Three-Tier Wall Hanging

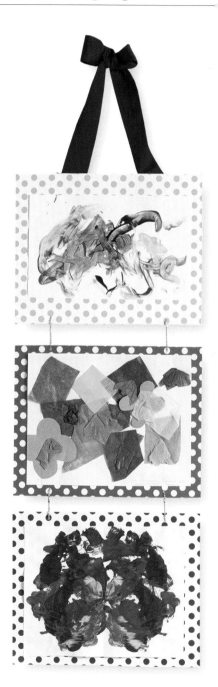

O nce you get the hang of mounting art on foam core, try making a wall hanging out of foam core and patterned paper. Here, the art is tacked on each panel with Velcro so it's easy to change the show. Connect the panels with keychain-type chains, available in craft stores, or binder rings, available in office-supply stores.

Making wall hangings is a fun way to enjoy patterned paper outside a scrapbook. Here, the bold dot patterns are just the right background for a two-year-old's projects. The subtle papers in the sheet protector display (Tip #8) serve as more conventional and neutral mats.

SUPPLIES Foam core, three pieces of 8½ x 11" patterned paper, four small linked key chain bracelets, metal ruler, utility knife, drill, 1 yard 1½" grosgrain ribbon, hot glue, glue stick, Velcro, art. **INSTRUCTIONS** Mount paper to foam core with glue stick. Using a metal ruler and utility knife, cut three 8½ x 11" pieces of foam core. Drill two small holes where the foam core panels will connect: at bottom of top panel, top and bottom of middle panel, and top of bottom panel. Connect all three pieces of foam with key chain bracelets. Place short piece of Velcro in middle of each piece of foam core (complementary piece will be mounted on back of child's art, making it interchangeable). Tie bow in middle of ribbon and hot glue ends to back side of top foam core sheet. Hang from ribbon.

Sheet Protector Display

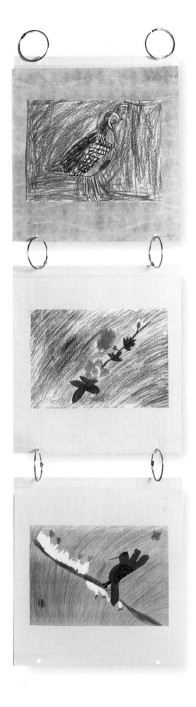

I f you're a scrapbooker, you've got sheet protectors. If not, sheet protectors are only as far as your nearest office-supply or craft store. You can use them to create an easy and inexpensive way of displaying a series of themed pictures while protecting the art from dust and little fingers. Keep the wall hanging up but replace the art with a fresh crop every few months.

SUPPLIES Three 12 x 12" sheet protectors, three 12 x 12" sheets Flavia scrapbook paper, Acco Loose Leaf Rings (2"), hole punch, photo mounts, three pieces of artwork (preferably with same theme). **INSTRUCTIONS** Color copy three pieces of art, reducing or enlarging so they are the same dimension, trimming as necessary. Mat each on a 12 x 12" scrapbook page with neutral color, pattern, or texture. Colors should be similar to unify the wall hanging. Secure color copies of art to background with a single photo mount at center (to allow for easy switching). Insert paper into sheet protectors and arrange art from top to bottom. Using the connecting sheet protectors as a guide, punch holes at the bottom of two of the sheet protectors. Attach rings.

IDEA TO NOTE Sheet protector displays can be hung on two small hooks on a wall or on two small suction cup hooks on a window. If displaying in a window, choose art that is translucent so light shining through window will illuminate art.

Mobiles and Collages

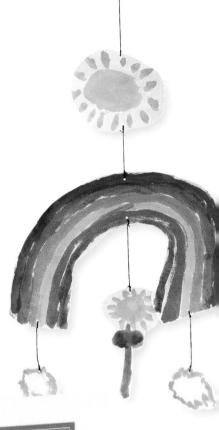

Make a mobile or collage from any work of art that can be cut into individual images. But first, let your child in on your plans for his or her creation to avoid misunderstandings.

Nativity collage
SUPPLIES Pre-cut acid-free mat, card-stock, photo mounts, copy of art. **INSTRUCTIONS** Cut out individual images and arrange.

Rainbow mobile
SUPPLIES Needle, thread, double-stick tape, two color copies of art. **INSTRUCTIONS** Cut art into individual images. Lay copies back-to-back, secure with tape, and trim. Lay images out as you wish them to be spaced. Connect cutouts with double piece of thread, using needle to puncture paper. Tie thread securely.

Clipboard Frames

The fastest way to frame a picture is to put it on a clipboard that you've made into a frame. Paint a plain, old-fashioned brown clipboard, or use die cuts and scrapbook papers to make a frame that works equally well for art and for schoolwork. Hang from metal loop at back of board.

Clipboard frames are great for temporary displays, but since they won't protect the art from dust, move more precious pieces into safer storage after enjoying them this way for a while.

Crayons frame

SUPPLIES Clipboard painted with black acrylic paint, Frances Meyer patterned paper, Cock-A-Doodle Design die cuts, Sailor 2 in 1 glue pen. **INSTRUCTIONS** Center patterned paper on clipboard and glue. Glue on die cuts.

Painted frame

SUPPLIES Clipboard, acrylic craft paint, foam beads, red shoe lace, black marker, hot glue gun. **INSTRUCTIONS** Using the marker, sketch large loops and zigzags over entire clipboard. Paint spaces with solid colors. When paint is dry, knot foam beads on shoe lace and hot glue in place. Clip on art and display.

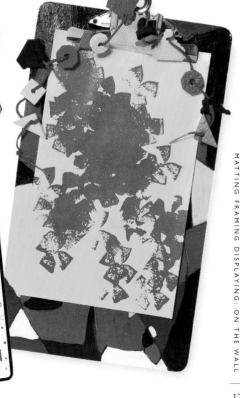

Craft Stick Frames

Use craft sticks to make inexpensive frames for displaying art. Leave them natural or paint them using paint from the artwork inside. Craft sticks are available by the box at craft stores.

Elephant
SUPPLES Pink cardstock, Aleene's Tacky Glue, art. **INSTRUCTIONS** Copy line drawing on cardstock, reducing if necessary, but leaving lots of room around drawing. Assemble craft sticks as shown and glue to cardstock.

Painted sticks
SUPPLES Cardboard, Crayola Washable Kids Paint, Aleene's Tacky Glue, double-stick tape, coordinating ribbons, paintings.

INSTRUCTIONS Secure corners of picture to a slightly larger piece of cardboard with double-stick tape. Paint craft sticks (art shown was made with same paint mom used to paint frame). Arrange sticks to make frame and glue overlaps with tacky glue; then glue frame to cardboard. To make hanger, tie a bow in the center of a piece of coordinating ribbon and glue ends to back of frame with tacky glue.

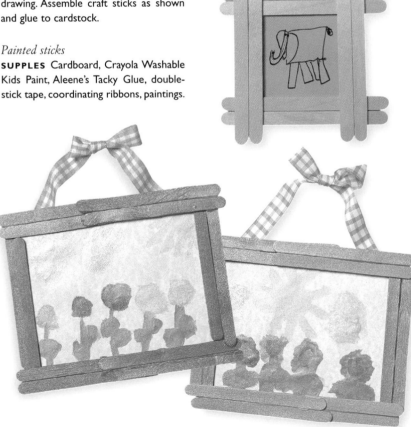

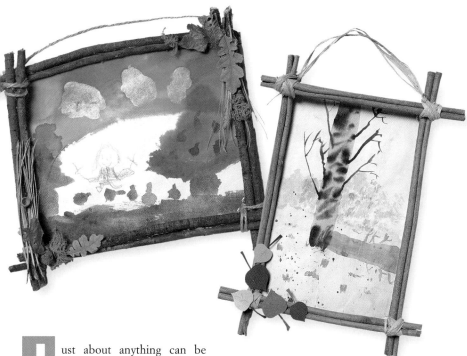

Just about anything can be made into a frame. Cinnamon sticks look and smell good, and the twig frame, holding a picture inspired by a nature walk, displays treasures from the walk including feathers, moss, and leaves.

Twig frame
SUPPLIES Sticks, garden pruner, cardboard, small natural objects, twine, adhesive, hot glue gun, art. **INSTRUCTIONS** Attach artwork to cardboard. Arrange sticks in pairs to form frame, trimming with garden pruner. Hot glue two sticks together for each side of frame and lash at corners with twine. Hot glue stick frame to cardboard. Hot glue natural objects to twigs. Tie a piece of twine to top corners of frame for hanger.

Cinnamon stick frame
SUPPLIES Eight long cinnamon sticks (from craft store), leaves cut from cardstock, cardstock for backing, serrated knife, raffia, photo mounts, hot glue gun, art. **INSTRUCTIONS** Attach art to cardstock with photo mounts. Arrange cinnamon sticks in pairs to form frame, trimming with serrated knife. Hot glue sticks together. Lash corners with raffia wrapped in an X shape. Secure raffia on back with hot glue and hot glue frame to cardstock at corners. Glue cutout leaves.

19

Professional Framing

Sometimes a piece of artwork is so special it deserves to be framed by a professional, who has access to a much wider variety of frame styles and colors than would be found in a craft store. Take part in the process, or leave the decisions to the framer. Make certain the frame shop uses archival-quality (acid-free and permanent) materials to assure the long-term survival of your treasures. To protect artwork from the damaging rays of the sun, consider UV-protected glass if it's within your budget.

Pumpkins

The green mat perfectly matches the color of the three pumpkin stems. The mat's narrow border complements the painting's simplicity, as does the use of a neutral second mat and choice of a simple, wood frame.

Self-portrait

The strong, solid color of the outer mat doesn't compete with the busy background and the artist's colorful T-shirt. The narrow border of light green draws out the pastel images of the wallpaper.

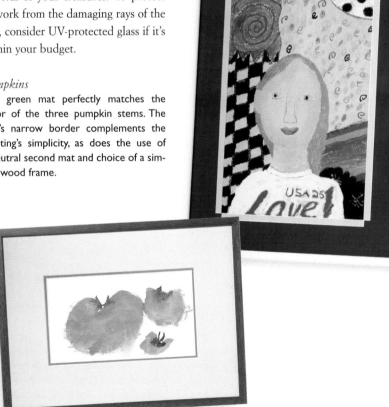

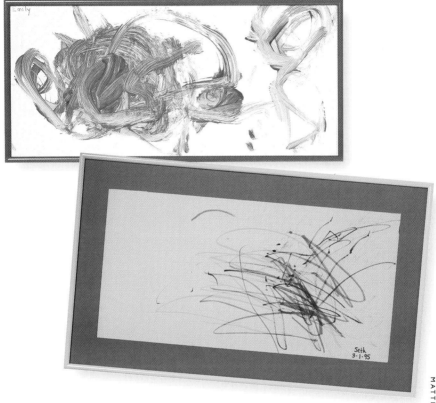

An abstract piece of art from even the youngest child can look beautiful—especially when professionally framed and matted. To a toddler or a preschooler, these pictures may just be fun explorations with markers or paint. But beauty is in the eye of the beholder, so it's up to a watchful parent to spot an especially pleasing, decorative image and single it out for public display.

Purple frame
This painting is all about color—which is what the child was enjoying when she made the picture. The frame serves to highlight this, and is effective even without the use of a mat.

Yellow frame
The concentration of scribbles on just one side of the paper gives this rectangular art an interesting composition. The decision not to crop any of the blank space at left was intentional.

MATTING FRAMING DISPLAYING: ON THE WALL

21

The Story Behind the Picture

Sometimes the words on a piece of art can be just as important as the image. The artist (who had this professionally framed as an adult) wanted to include what she'd written about the old houses in Amsterdam that so impressed her. But the text was too long and threw the front of the picture off balance. Instead, she framed the picture with just one line and had the framer position the rest of the text on the back. This way, all the facts were saved and the first sentence acts as a caption to her drawing.

Consider asking your child to write a few words about his or her picture on a separate piece of paper: the who, what, when, where, and why of the drawing. If the notes don't look right framed with the art, attach them to the back. In years to come, your child will appreciate the memory of making a picture that mom went to the trouble to frame!

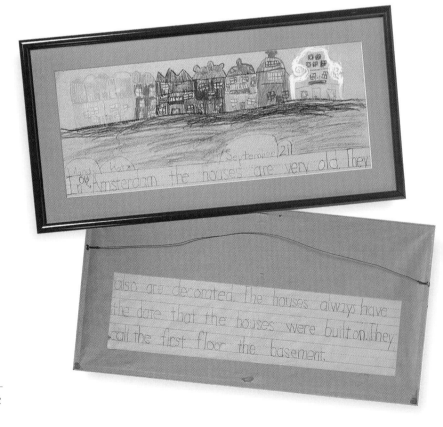

Twine-and-Clothespin Display

Create your own homemade gallery with twine and painted wooden clothespins. Mom can do the painting or enlist young helpers. Or, let each child paint a set of clips to hang his own work. Rotate artwork as new masterpieces come in. This casual display looks great in country-style kitchens, playrooms, and bedrooms. For safety, be sure to hang the twine high enough so it's out of reach of younger children.

This simple display can work with art of different sizes. Here, extra-large art was copied and reduced to a uniform 8½ x 11" size to accommodate the space available for the display.

Clothespin displays don't offer original art protection against dust, another reason to consider making color copies before hanging masterpieces this way. But clothespins are much less damag-ing to art than tape used to affix it to a refrigerator or wall.

Hand-painted wooden clothespins are sometimes available from upscale houseware stores and mail-order catalogues—keep a watch for them. Prepackaged clothespin kits such as Art Hang Ups include plastic clips in primary colors, white nylon clothesline, and mounting hardware. See Resources.

Twine-and-clothespin display
SUPPLIES A length of twine, jute, or ribbon; hinged clothespins (the kind you squeeze to open), Crayola Washable Kids Paint, art. **INSTRUCTIONS** Paint clothespins. Once they're dry, go back and paint designs with contrasting colors. Knot the ends of the twine to prevent raveling. Tie small loops (to hang on walls) near the ends of the twine, and one in the middle if needed for support. Attach artwork to the twine with clothespins.

Stuffed Animal Chain

B uy a simple stuffed animal chain (available in the toy section of large discount stores) to display art quickly in an inexpensive, neat way. The trick is to hang the chain horizontally, not vertically! There are usually about twenty plastic clips to a box, so there will be plenty of them to go around for all those pieces of art that need to be displayed.

The brass components of the clips and clean white-plastic links of this simple chain look terrific against a white wall. Select pieces of artwork that share a common characteristic.

For example, this particular display features translucent art and could just as easily be hung in front of a large window or above a sliding glass door to allow sunlight to filter through.

For safety, be sure to hang the chain high enough so the dangling pieces of artwork are well out of reach of younger children.

Chain
SUPPLIES Bajer's Treasure Chain, including a 6-foot plastic chain and hooks for installation, artwork. **INSTRUCTIONS** Hang horizontally on wall or in front of window. With clips, attach artwork to chain.

Dowel Display

An unusual way of showcasing your children's art is to hang it on a homemade dowel display. The three decorative shapes here were selected to match the art.

SUPPLIES 24" dowel, two wood knobs, two 9" square wood frames, one 11" square wood frame, drill, twine, three large flat-head screws, three pieces of scrap wood ¾" square and ⅜" thick, three ceramic shapes, acrylic paint, foam paint brushes, finishing spray, glue gun and staple gun. **INSTRUCTIONS** Paint frames, knobs, and dowel using acrylics and foam brushes. Let paint dry. Seal with finishing spray, letting first coat dry for one hour before applying second coat. Hot glue wooden knobs to ends of dowel with glue gun, holding in place for approximately three minutes. Using a drill bit smaller than the diameter of the screws, drill three holes through the scrap wood and into the dowel at 6" intervals along the dowel. Screw screws through scrap wood and dowel, then unscrew so there's a ⅛" space between dowel and wood scrap. Hot glue ceramic shapes to heads of screws and hold in place until dry. To hang picture frames, use staple gun to affix desired hanging length of twine to back of each frame and hang from screw. To hang dowel (see cover), tie a long piece of twine around each end of dowel and staple to keep knots in place.

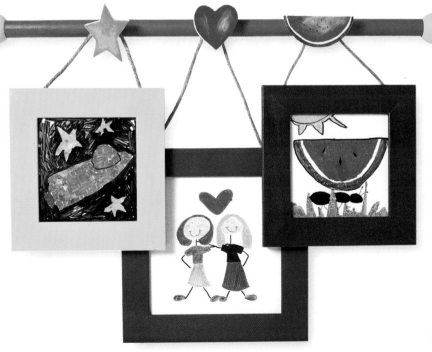

MATTING FRAMING DISPLAYING: ON THE WALL

Art Gallery Frames: Wallies

SUPPLIES Architectural Group Wallies, Architectural Rope Wallies, ruler, pencil, damp sponge. **INSTRUCTIONS** With pencil and ruler, lightly outline a rectangle about 1" larger all around than the largest piece of art. Moisten Wallies with a sponge. Affix Rope Wallies directly over the pencil outline, overlapping sections to match patterns. Add corner Wallies last.

Make an art gallery for an ever-changing art show in your home with permanent frames. Prepasted wall-paper cutouts such as Wallies offer a quick way to get frames on the wall, and they can be easily stripped when you want to redecorate.

When planning your permanent-frame gallery, notice the paper sizes your child's school uses for art projects. Many provide a 12 x 18" sheet for the largest projects and a 9 x 12" sheet for smaller ones, as shown on this wall. They may also use special papers or smaller scrap papers for different purposes. Check with the art teacher to get a sense of the size range.

Alternately, collect old, empty frames at flea markets, paint them gold or silver, and hang them on the wall to create a three-dimensional variation. A group display will enhance all the art.

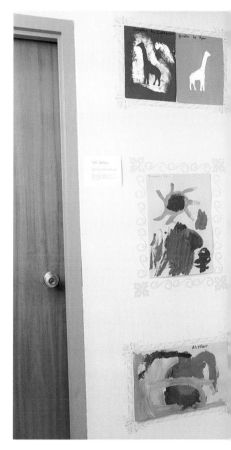

Art Gallery Frames: Stamps

Stamping frames with paint that's just a few shades darker than your wall color is a subtle way to add permanent frames to your home art gallery. When designing your frame, keep it simple. Too many colors or different stamps in a frame can distract from the art within. Experiment first on a painted cardboard box.

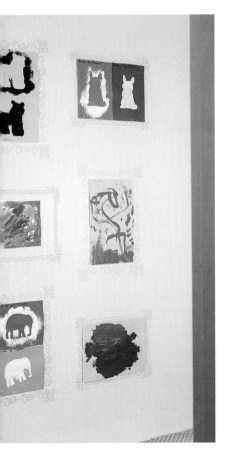

SUPPLIES Rubber Stampede swirl and decorative scroll stamps, Duron latex paint (wall: Whispering Birch; stamp: Millet), 3" paint roller, ruler, pencil. **INSTRUCTIONS** With pencil and ruler, lightly outline a rectangle about 1" larger all around than the largest piece of art you want to hang. Before applying paint, check the horizontal and vertical parts of the rectangle to make sure you can fit a row of scroll stamps without any overlapping. Adjust accordingly. Apply paint to stamp with paint roller. Stamp swirls in four corners first, in horizontal and vertical parts of frame second, making sure stamps do not overlap. Apply pressure evenly when stamping.

Scrapbooking has revolution-ized the way families save photos and memorabilia. When people began realizing that both magnetic and many kinds of paper albums were highly acidic and caused photos to turn yellow and fade, they began looking for safer ways to protect family pictures.

Today there is an abundance of col-orful, decorative, acid-free materials to choose from for preserving photos and celebrating good times. The same great supplies and ideas that go into making scrapbook pages for photos can also be used for pages celebrating chil-dren's art. But the art kids bring home from school has its own special set of preservation concerns. Most schools use inexpensive paper that fades quickly and will deteriorate over time. And the washable paints and markers children work with are impermanent by nature. Fortunately, a few simple precautions and techniques can extend the life of these important keepsakes.

The Best Way to Preserve Original Art

- To neutralize the acid in an origi-nal piece of art, spray it front and back with a deacidification spray such as Archival Mist. Follow directions on bottle closely.
- Place flat in acid-free portfolios, file folders, or boxes.

SUPPLIES Patterned paper, pink cardstock, photo mounts, color copy of artwork.

- Store in a cool, dry, dark place.
- Don't cut or crop original art.

Use Copies for Display

- Use copies instead of originals when framing art.
- Look for interesting details that can be enlarged to make their own pleasing picture.

Rating the Reproductions

You can copy art by using a commercial color copier, photography, or a computer set up with a scanner and color inkjet printer.

- A color copy from a copy machine will last the longest if it's made on a commercial copier that uses powder toner. Check that paper is acid-free, too; many office papers today are.
- Color photos nowadays will maintain their color longer than they used to, but will eventually fade.
- Copies from color inkjet printers are least stable and are especially vulnerable to the effects of humidity. (As a test, run a sample under cold water. The colors will bleed, meaning the ink is not permanent.)

Scrapbooking Tips

When displaying art in scrapbooks, it's okay to use originals if they fit on your page without cropping. Use copies if art has to be reduced, enlarged, cut, cropped, or otherwise manipulated.

- Use acid-free materials.
- Non acid-free materials included in a scrapbook should be sprayed

with a deacidification spray. Keep in mind that placing acidic items on top of artwork will speed the art's deterioration.

- Journal with permanent ink: other types of ink will fade. But don't write on the artwork.
- Be aware that art that is laminated by conventional means, spray mounted, or stored in a non acid-free container will eventually be damaged by the high acidity levels of these materials.

Using a Xyron Machine

Try using a Xyron machine to apply adhesives or lamination to items you want to include in your scrapbook. These machines, which come in three different sizes, work without heat or electricity and apply a smooth, sticker adhesive that's acid-free and safe for your scrapbook. They can also apply a double-sided polypropylene lamination that seals in any damaging substances. This lets you include memorabilia and decorative items that would normally be too bulky or acidic for a scrapbook page, such as crinkled tissue paper or dried flowers. Don't laminate important documents such as heirloom photos or birth certificates since the process can be damaging and is irreversible.

Whether you want your child's art to last a few extra years or be handed down to future generations, some precautions will ensure your future enjoyment of these priceless treasures.

Mini Scrapbooks

Create a theme scrapbook dedicated to a child's artistic output. A spiral notebook filled with cropped photos of favorite sculptures and paintings becomes an elegant catalogue. "You're Invited" celebrates the dozens of pictures of people in party clothes drawn by a five-year-old girl.

Spiral-bound art catalogue
SUPPLIES Paper Reflections spiral-bound blank book, photo mounts, photos of art.
INSTRUCTIONS Crop photos to remove unnecessary background and create uniform sizes. Organize chronologically or thematically. Mount. Pencil in child's age.

Saddle-stitched album
SUPPLIES Kolo Rona 7 x 7⅞" album, Paper Adventures large yellow polka dot paper, Paper Patch solid purple, pink, yellow, and green polka dot paper, Creative Memories blue paper, Pebbles in my Pocket olive green paper, DMD cream paper, Print Works mulberry paper, Making Memories Little Letters, Oscrap-Imagination assorted die cuts, Oscrap-Imagination flower frame, Creative Memories corner rounder, Provo Craft Oval Coluzzle oval cropping, All Night Media square punch.

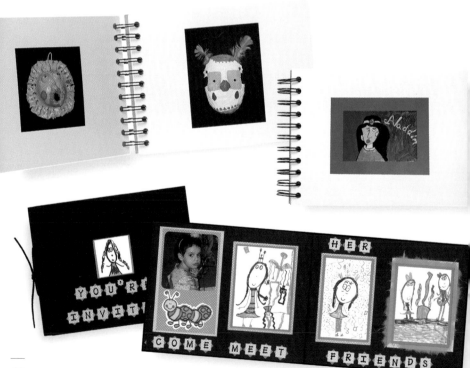

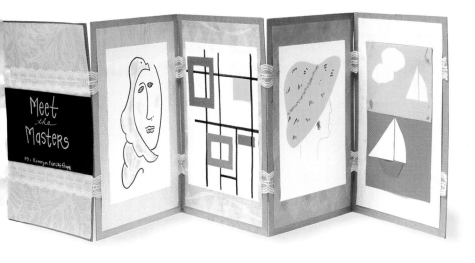

Whether you make them by hand or buy them ready-made, accordion books are a creative way to scrapbook color copies of children's art since they easily open to display several pieces at once or fold flat for storage. The accordion book above, with its sturdy 8½ x 11" pages, was made by hand, but you can also purchase smaller accordion books intended for use with snapshots (by Kolo and Books by Hand, for example) and take photographs of art or make reduced color copies. This type of display is perfect for showing off pictures related by theme.

SUPPLIES Cardboard, Flavia decorative paper and vellum, photo mounts, spray mount or glue stick, Aleene's Tacky Glue, lace, Silver Metallic Opaque Writer, art. **INSTRUCTIONS** Set up cardboard pieces the way you want them to appear, leaving a space twice the thickness of the cardboard between them. Cut two pieces of lace a foot longer than the combined widths of cardboard; the extra foot should hang over the left side of the panel that will be your cover. Using tacky glue, glue the two pieces of lace in parallel rows across cardboard, one closer to the top and one closer to the bottom. Let dry. Flip and do the same thing to reverse side, making sure the extra foot of lace hangs over the back of the cover panel (just as the front piece of lace does). Let dry. Tie bows. Using vellum, black cardstock, and metallic writer, create a cover with your child's name. Crop and mount copies using photo mounts.

Framing Art for Your Scrapbook

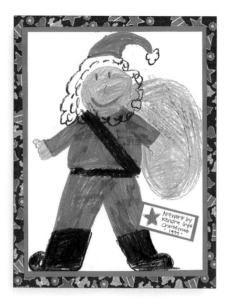

The simplest way to include your child's art in your scrapbooks is to use originals or copies that fit easily on your page and then frame them using your favorite scrapbooking papers and materials. Add some simple journaling to record the date or occasion.

Christmas 1999
SUPPLIES Paper Patch paper, white cardstock, photo mounts, art.

Brown bear
SUPPLIES Paper Patch patterned paper, brown photo corners, photo mounts, art.

Autumn tree
SUPPLIES Cardstock, art.

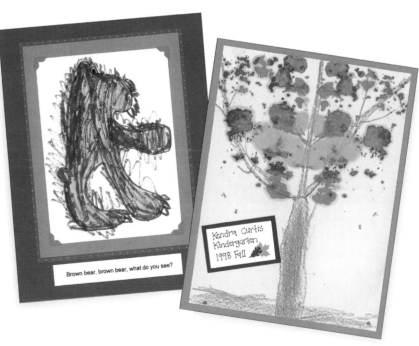

Brown bear, brown bear, what do you see?

A Portrait with the Picture

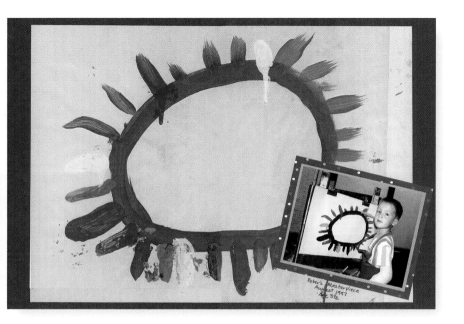

Peter's Masterpiece
August 1997
Age 3½

Take photos of a work in progress and display alongside the finished product using colors that tie the two together. One little artist was right in the middle of applying the finishing touches to his masterpiece when his mom snapped this picture.

Large-scale pieces like this one, done on paper typically used for youngster's paintings, quickly deteriorate and are hard to store. By taking the painting to a copy center and making an 8½ x 11" copy of each half of the picture, which she pieced together and mounted on coordinating cardstock, this mom made a permanent version of her son's paint-ing just the right size for a large scrap-book-page spread. The photograph, simply framed and positioned off to the side, tells the story, recording for-ever the age and interest of the artist.

> **IDEA TO NOTE:** Occasionally when visiting your child's school, camp, or recreation center, take your camera. A simple "point and shoot" camera works fine for just such casual situations. If this mom had forgotten hers this moment might have been forgotten.

SUPPLIES Yellow and purple cardstock, Paper Patch polka dot paper in coordinating colors, photo mounts, art.

The Next Picasso

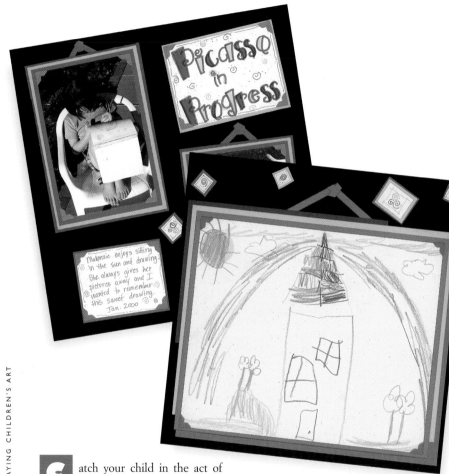

Makenzie enjoys sitting in the sun and drawing. She always gives her pictures away, and I wanted to remember this sweet drawing. Jan. 2000

Catch your child in the act of creating . . . is she the next Picasso? Candid shots of an artist at work tell a lot about how important drawing is to the youngster and can show the intensity of a creative moment. After seeing the artist concentrating so hard, it's a treat to view the finished result, displayed with simple embellishments that enhance the art without detracting from it. The use of black background paper draws attention to the vibrant colors of the pictures and matting materials.

Picasso in Progress
SUPPLIES Cardstock, Zig Writer, Boston photo corners, Hermafix photo tabs.

Profiling the Artist

Another way to preserve art for your scrapbook is by profiling the artist. Whether your child is a prolific painter or a reluctant scribbler, the way art fits into his life is one window into his personality.

Artist at work
SUPPLIES Paper Patch dot paper, Fiskars crimper (crayons), Zig Opaque Writer, photo, original art.

Pete is neat
SUPPLIES Paper Patch blue check paper, font Anything Goes by *The Best of Creative Lettering CD 1,* Fiskars paper trimmer, Zig Opaque Writer (EK Succcess), Pokemon Color Your Own Stickers, Nintendo, licensed by Rose Art.

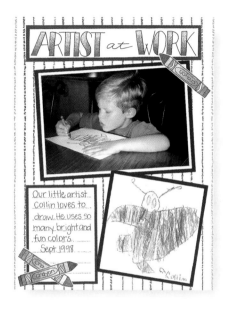

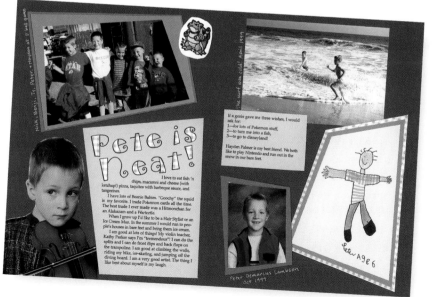

Foolproof School Pages

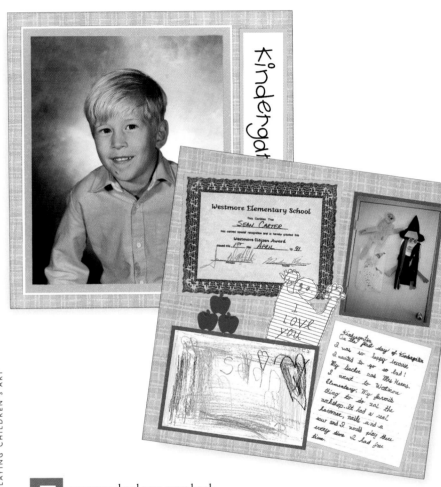

For every school year, scrapbook artist Kim McCrary makes a scrapbook spread with the highlights: school photo, certificates, best art, and best writing samples. The result is a quick summary of each child's interests and abilities at a particular point in time. A uniform format makes it easy to watch a child's talents develop.

Kindergarten

SUPPLIES Paper Patch background paper by Keeping Memories Alive, apple punch, Marvy Uchida, teardrop punch, McGill, font Scrap Kids from *Lettering Delights* Vol. I, (Inspire Graphics), photo mounts, original photos, copies of notes, reduced color copies of art.

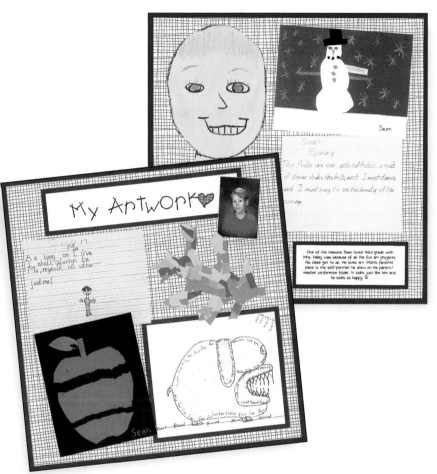

Most children will produce much more art in a year than can possibly fit on a summary school-year page (see Tip # 27). Another way to save art showing a child's interests and abilities is to make special pages devoted to showcasing favorite pieces of art. These pages are special because of the variety of art, the small school photo of the artist, and his journaling.

My Artwork

SUPPLIES Close To My Heart D.O.T.S. background paper, letter and heart stamps, dark cardstock to mount white pages on, computer-generated lettering, photo mounts, color copies of art.

Showcasing 3-D Art

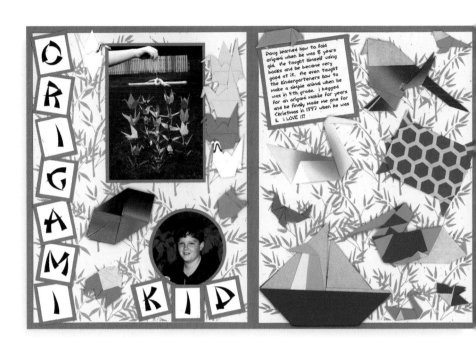

One way to showcase three-dimensional art in a scrapbook is to photograph it, on its own or with the artist in the shot. Sometimes, though, the three-dimensional creations can be preserved right in your scrapbook. In the pages above, the young artist had become an origami expert and his scrapbooking mom saved samples by pressing them flat.

Origami Kid

SUPPLIES Font Scrap Samurai from *Lettering Delights*, photo mounts, photos, art.

Turkey pumpkin

SUPPLIES Patterned paper, colored cardstock, photo mounts, photo of art.

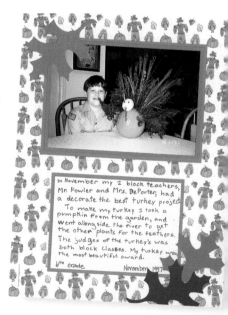

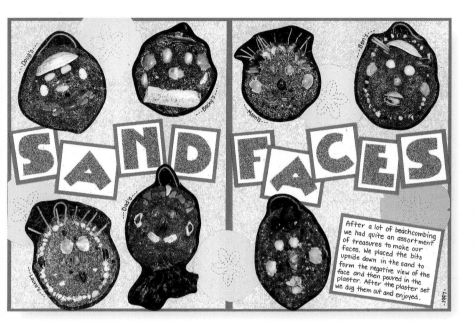

After a lot of beachcombing we had quite an assortment of treasures to make our faces. We placed the bits upside down in the sand to form the negative view of the face and then poured in the plaster. After the plaster set we dug them out and enjoyed.

Sometimes a child falls in love with a subject or a technique and makes the same kind of picture over and over again. The products of a phase like this make wonderful subjects to scrapbook.

These pages record a day when a whole family became engaged by an art project. Mom and dad showed their children how to make reverse-image faces in the sand at the beach (seashells used for eyes had to be placed upside down in the sand, for example). After everyone made a unique design in a little scooped-out circle of sand, mom carefully poured plaster into each circle. (They had brought the plaster from home, in a bucket.) About a half-hour later, the plaster was hard and the sand sculptures were done.

In making this page, mom effectively used a variety of scrapbooking techniques. She trimmed photos of the faces into circular shapes, used a mottled-looking background paper, and cut her lettering out of real sandpaper! Her journaling tells the story of their unusual adventure.

Sandfaces

SUPPLIES Provo Craft decorative paper, Back to Nature papers, Ellison die cuts, Letter Stencil, sandpaper, photos.

A Rotating Wheel for Art

ne young artist was so fasci-
nated by the movie *Tarzan* that
he sketched the characters for hours.
The rotating wheel shows several of his
views of Tarzan.

SUPPLIES Light blue and white card-
stock, brown tissue paper, Ellison die-cut
jungle leaves, green tissue paper, Craf-T
chalks (around sketch book), Fiskars scallop
scissors (pencil), Provo Craft "log" letters,

Xyron, Askars crimper, All Night Media
spiral punch, round head brass paper fas-
tener, compass, black and white copies of
art. **INSTRUCTIONS** Cut cover page of
notebook out of background cardstock.
With compass, draw circle 11" in diame-
ter on another piece of cardstock. Cut
out. Divide into four equal parts with pen-
cil. Glue a sketch in each quadrant so it
shows through window. Attach to back-
ground cardstock using fastener. Slice
sheet protector so wheel can be turned.

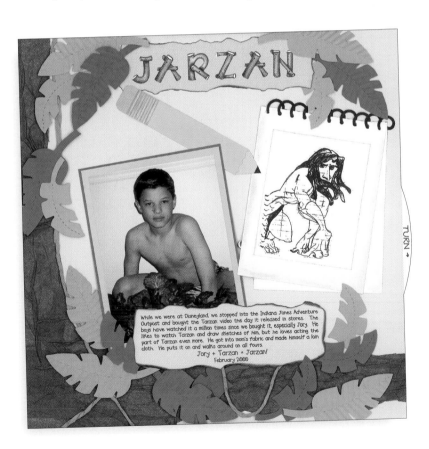

Cutout Enhancements

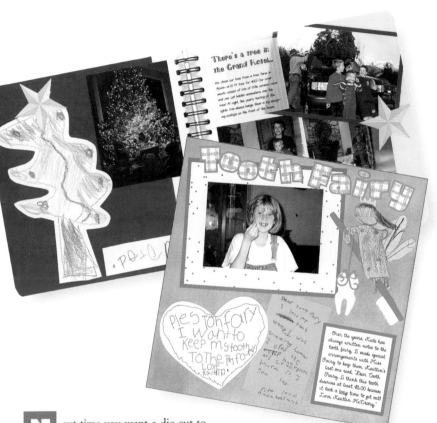

Next time you want a die cut to enhance a scrapbook page, try looking through your children's art. A drawing by a child, color copied and cut out, will give family and children's pages more meaning than would a store-bought die cut. You can enlarge or reduce the image to fit your page layout, as was done with the Christmas tree and tooth fairy in the pages above.

There's a tree in the Grand Hotel . . .
SUPPLIES Paper Preserves spiral-bound 10 x 10" album, red cardstock, star by Wallies, caption font Anything Goes, narrative font CK Print, both from *The Best of Creative Keepsakes Lettering CD 1*, art.

Tooth Fairy
SUPPLIES Close To My Heart (D.O.T.S.) background and patterned paper, Ellison (toothbrush & tooth) die cuts, Family Treasures heart & spiral punches, Fiskars, Soft-grips small heart punch, fonts Fancy, Fantastic by DJ Inkers, Frances Meyer lettering template.

Bring a Sketch to Life

Children love to draw their own versions of favorite activities. Include a copy of their sketches on the page along with your photos. If the picture is a simple pencil sketch, it may not be a strong enough image to enhance the page. In that case, make your own paper-pieced cutout of the image. Enlarge the sketch on a copy machine and make templates for use with different colors of cardstock. The wild surfer on this page shows how much fun everyone was having on T Street Beach and gets us to look twice at Carson's original drawing.

SUPPLIES Red and white cardstock, corrugated paper, Provo Craft Zany Zoo Sky background paper, scrapbooking marker, black Micron pen .05, paintbrush dipped in water, Provo Craft decorative scissors, art.

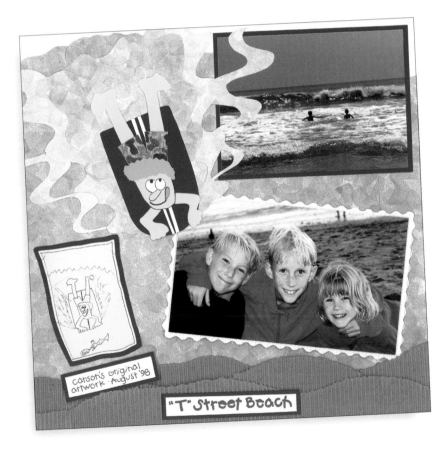

Carson's original artwork · August '98

"T" Street Beach

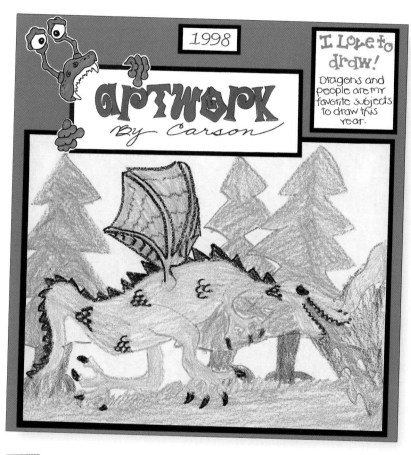

If you're doing a simple page to frame an original or photocopied piece of your child's art and want an enhancement that won't overpower the picture, look to the subject for inspiration. On this page, mom re-drew the fire-breathing dragon in her son's crayon drawing on cardstock and cut it out, essentially making a custom die cut. Mom's version of the dragon, which holds up the label announcing his artwork, is like a salute to her son's developing creativity. If you can't draw your own enhancements, look for die cuts or stickers that complement but don't compete with your child's art.

SUPPLIES Colored cardstock, Prisma pencils, Provo Craft clear acrylic stamp Gorg, Provo Craft letters Alphabitties, art.

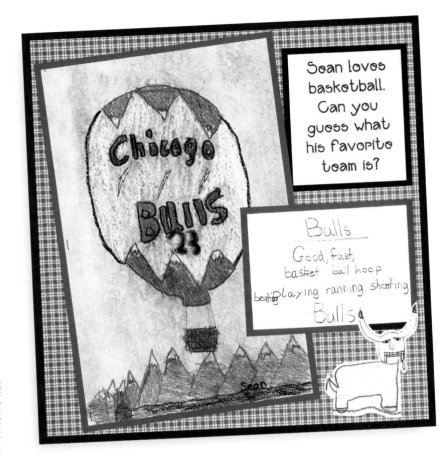

Sean loves basketball. Can you guess what his favorite team is?

Bulls
Good, fast, basket ball hoop
beating Playing running shooting
Bulls

When a child draws pictures related to his current sports passion, it's a scrapbooking springboard! Collect other evidence of interest—a poem written for a school assignment, a picture of a mascot—or conduct a brief interview with your child as you prepare to make your page. Artwork can be copied, reduced, or even enlarged to create a visually dramatic focus. Matting this piece of art on red cardstock draws the eye to the Chicago Bulls lettering on the balloon. Keep your background simple (perhaps selecting team colors) and you'll have a page your child may be as passionate about as his or her sport.

SUPPLIES Paper Adventures background paper, fonts Outline, Fantastic by DJ Inkers, color copy of art.

Art as Background Paper

Abstract art from younger children translates well into background paper. The simplest way to go about this is to enlarge the art on a color copier or use a scanner and color printer. To make background paper for a 12 x 12" page, try enlarging or reducing the art to an 11 x 11" size (by copying it onto 11 x 17" paper) and selecting a coordinating patterned paper as a frame. Use the combination as backdrop for photos, journaling, and stickers.

SUPPLIES Provo Craft decorative paper, vellum, Stickopotamus Art stickers, Zig Writer pens, photo mounts, photocopy of art, photos of art and artist.

> **IDEA TO NOTE:** Writing part of the page title on vellum lets you enjoy the art underneath.

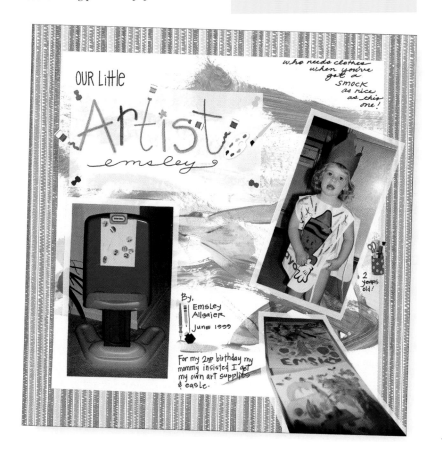

Handwriting is Art, Too!

The way your child writes at different stages of schooling captures his or her developmental level. And when children write down what they're thinking, they often reveal an innocence that's the essence of childhood. Preserve a few samples of your child's writing, especially when the content is surprising or endearing.

Santa letter
SUPPLIES Cardstock, photo mounts, color copy of original letter.

Passing notes
SUPPLIES Pebbles in My Pocket cardstock, photo mounts, photocopy of note.

IDEA TO NOTE: Let the writing be the center of attention on your page just as you'd let the photos or the art be the main attraction on another page.

A note that comes from the heart is a scrapbooking opportunity. "Turtle's a joy in our family" writes Amber on a card to her cousin, and this inspired a scrapbook page that grew to include a copy of the turtle's adoption certificate and photos of family members. Another note revealed a sweet childhood misunderstanding. Brandon mistook an IOU from his dad for a love note, so he signed his name to it and passed it on to his mother.

Turtle

SUPPLIES Color cardstock, copy of adoption certificate, Pigma Micron pen, photo mounts, photos.

IOU

SUPPLIES Pebbles in My Pocket cardstock, photo mounts, reduced color photocopy of money, photocopy of note.

Art displays don't have to be limited to walls and scrapbooks. Using photography, color copiers, and computer scanners, art can be reduced, enlarged, and rearranged in dozens of ways, allowing it to appear on anything from miniature refrigerator magnets to plates, trays, clothing, games, and even quilts!

The best part about working with copies of your child's art is that the original can be preserved: a comforting thought to the child who might wince at the sight of his masterpiece being cut up or cropped. Show your child that you're saving the original in acid-free containers. Confident that his art is safely stored, the child will feel free to help with ideas on how a favorite piece can be transformed into functional displays that can be enjoyed at home or given as gifts.

Benefits of Using Photos, Color Copies, and Computer Scans

- Photos reduce art to a good size for small-scale crafts with one click of the shutter. The glossy finish of photos may be the best effect for certain projects.
- The color of color copies tends to be truer to the original than it would be in a photograph where lighting, exposure, film type, developing, and background color may affect overall hue.
- Scanning into a computer lets you play with details and experiment with size, cropping, and silhouet-

SUPPLIES Cardstock, magnet, adhesive, photo of art.

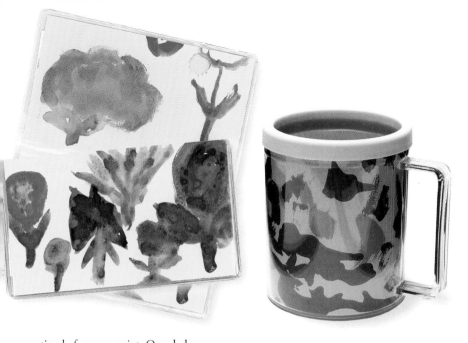

ting before you print. One dad scanned his preschooler's abstract painting but printed only one very beautiful swirl.

From Paper to Fabric

Special transfer papers made for use with color inkjet printers or commercial (powder toner) color copiers let you iron a drawing on fabric.

- For color inkjet printers, many brands of transfer papers are available at craft and office-supply stores. Before purchasing, carefully read the instructions for each brand to see which will be most suitable for your project. Some iron-on papers work when the paper completely cools, while others must be peeled off at a very specific point in the cooling process, such as after two minutes.
- For those who don't have scanners and color inkjet printers, the quilt-

Checkbook: **SUPPLIES** Show-Offs by Visual Image, color copy of artwork. *Mug:* **SUPPLIES** Design A-Mug, color copy of artwork.

book publisher Martingale sells a special transfer paper that can be used with commercial color copy machines.

- Smooth, white fabric works best with iron-on transfers. Heavy, color fabric (such as a gray sweatshirt) creates a less accurate reproduction, though you may like the effect.

So whether you want to display your children's creations in your own home or give them away as one-of-a-kind gifts, these homemade treasures will be wonderful keepsakes of your child's artistic expression.

Simple Refrigerator Magnets

E ven if the original is large, think small. Magnetize a color copy with Master Magnetics adhesive magnetic sheeting, use a Xyron machine to add a magnetic backing, or print out on your color printer with magnet-backed paper from Avery.

Snowman
SUPPLIES Cardstock, adhesive, magnet, photo of art. **INSTRUCTIONS** Mount photo on white cardstock, trim. Mount onto color cardstock. Apply magnet.

Clown
SUPPLIES Cardstock, adhesive, magnet, photo of art. **INSTRUCTIONS** Mount photo on cardstock, trim. Apply magnet.

Best friends
SUPPLIES Oval template, cardstock, adhesive, magnet, photo of art. **INSTRUCTIONS** Trim photo into oval using template. Cut larger oval from cardstock. Mount photo. Apply magnet.

Lauren
SUPPLIES Magnet, adhesive, color copy laminated at copy shop.

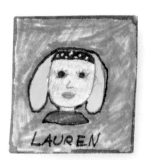

Little Refrigerator Frames

The beauty of putting art into neat little magnetic frames is the tidy display they make on the fridge. No need to hang papers from them—just line 'em up for admiring!

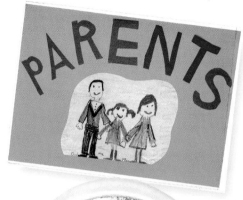

Parents
SUPPLIES Freez-A-Frame magnetic frame, photo of art. **INSTRUCTIONS** Trim photo, insert into frame.

Chloe
SUPPLIES Mini magnetic fridge frame, circle cutter, photo mounts, photo, art. **INSTRUCTIONS** Cut art with circle cutter. Mount photo on art. Write message. Slip into frame and display.

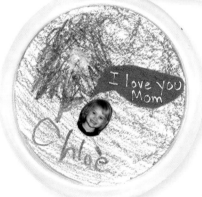

Red abstract
SUPPLIES AND INSTRUCTIONS Same as *Parents*, but put photo on cardstock.

Cherry
SUPPLIES 1⅛ x 1⅝" magnet frame (MCS Industries), trimmed color copy. **INSTRUCTIONS** Insert into frame.

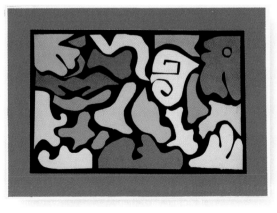

Refrigerator Collage

Create a collage with photos, color copies of art, and lettering under the acid-free film of a Display-it refrigerator frame. Make a special one to send Grandma, too!

Our little artist

SUPPLIES 13 x 17" frame, red and white cardstock, Provo Craft letter stickers, Mrs. Grossman's crayon stickers, Soft-Grips and Fiskars circle punches, Pigma Itoya pen, adhesive, photo, art. **INSTRUCTIONS** Create title with letter stickers. Trace around letters with black pen, leaving slight gap. Mount on cardstock. Add stickers. Arrange items and decorate.

Grandma's gallery

SUPPLIES 17 x 23" frame, die cuts and letters, red, white, and black cardstock, Frances Meyer hand stickers, O Scrap!: Imaginations crayon die cut, font CK Journaling from *The Best of Creative Lettering CD 2*, Fiskars Zipper scissors, adhesive, art. **INSTRUCTIONS** Create title. Mount on white and red cardstock. Arrange items in frame and decorate.

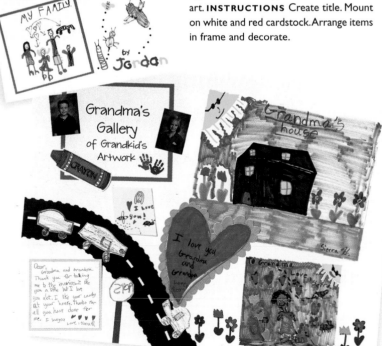

Big Refrigerator Frames

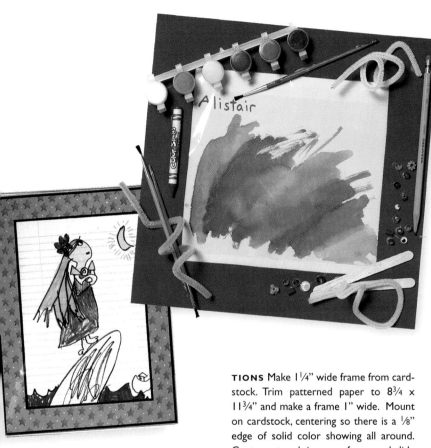

TIONS Make 1¼" wide frame from cardstock. Trim patterned paper to 8¾ x 11¾" and make a frame 1" wide. Mount on cardstock, centering so there is a ⅛" edge of solid color showing all around. Center artwork in paper frame and slide into fridge frame.

Purple art frame
SUPPLIES Purple craft foam, Master Magnetics self-adhesive magnetic sheeting, paintbrushes, paints, chenille sticks, googlie eyes, beads, pencil, crayons, art. **INSTRUCTIONS** Cut foam into 12 x 12" square. Cut center hole 8 x 8". Hot glue sheet protector to back of foam. Mount three 12" pieces of magnet to sealed sides of sheet protector. Decorate.

F rame art with patterned paper and cardstock before inserting it into a magnetized frame, or make your own frame from a sheet protector, craft foam, and art supplies.

Girl and moon
SUPPLIES 9 x 12" Fridge Frame (MCS Industries), Sonburn Blue Stars patterned paper, cardstock, adhesive, art. **INSTRUC-**

GIFTS AND HOME DECORATING: OFF THE WALL

53

Hooks and Clips for the Fridge

Some magnets simply are stronger than others. An industrial-strength magnetic bulldog clip from an office-supply store has a good strong hold, both on the fridge and the masterpiece. Make a gentler refrigerator clip with a clothespin. Put some self-adhesive magnetic sheeting on one side and secure a decorative image (such as a foam-core cutout or even a die cut) to the other. For three-dimensional art, try a suction-cup hook, which also works on windows and on some nonmetal refrigerator fronts.

Butterfly
SUPPLIES Adams medium suction cup with hook, three-dimensional art.

Christmas tree
SUPPLIES Acco Magnetic Bulldog Clip, color copy of art.

Pink abstract
SUPPLIES Wooden clothespin, pink craft foam, pen, beads, Master Magnetics self-adhesive magnetic sheeting, art.

Napkin Ring and Place Card

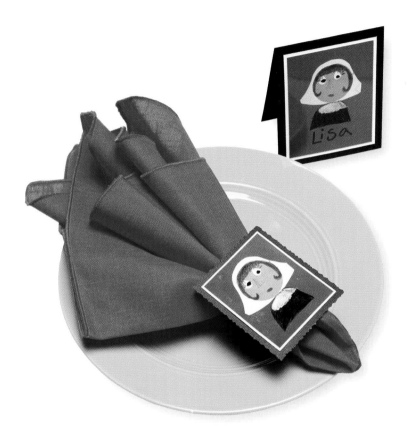

Make an elegant seasonal table-setting by using photos of the same piece of art for matching napkin rings and place cards. Coordinate cardstock backing and linens.

Place card
SUPPLIES White and black cardstock, Sigma Micron pen, adhesive, photo. **INSTRUCTIONS** Trim photo into rectangle, leaving room at bottom for name. Mount on larger rectangle of white cardstock. Mount this on larger rectangle of black cardstock, folded in half. Write guest's name with permanent pen.

Napkin ring
SUPPLIES White and black cardstock, Sigma Micron pen, adhesive, deckle-edge scissors, stapler, photo. **INSTRUCTIONS** Trim photo into rectangle, centering image. Mount on larger rectangle of white cardstock. Mount this on front of larger rectangle of black cardstock, trimmed with decorative scissors. Cut 1"-wide strip of black cardstock for ring. Staple ring, glue photo over staple.

55

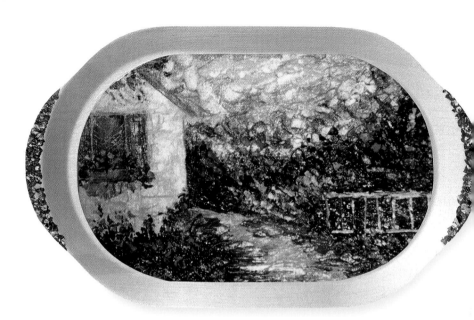

Make a favorite piece of art the focal point of a decoupage tray and discover a new way to enjoy your child's creativity. A ten-year-old made this Monet-like country scene! Her sister enlarged the image on a color copier and made a tray she uses for display and for serving dry foods. Tray should not be submerged in water but can be wiped clean.

Silver decoupage serving tray
SUPPLIES 20½ x 12½" Multi-Ply wood tray, Plaid decoupage kit, high gloss finish, silver craft paint, oil paint or artistic acrylic, palette knife, color copy of art. **INSTRUCTIONS** Paint tray desired color. Crop copy of art to fit central area. Follow decoupage kit instructions for gluing down art and covering with decoupage paste. Apply 2 coats and let dry overnight. Once set, apply high gloss finish. Dry. Using palette knife, paint tray handles to match child's artwork.

Octagonal plate (from p. 57)
INSTRUCTIONS Tear tissue paper into quarter-size pieces, secure to plate with Mod Podge, and cover all with Mod Podge. Make color copy of art, reduce, crop figure closely and affix to center of plate with Mod Podge. Paint around figure with blue paint; highlight blue paint with gold. Separate layers of paper napkin, tear into small pieces, coat with Mod Podge, and glue to plate with Mod Podge. Outline perimeter of plate with blue. Trace a thin gold line on top edge of plate.

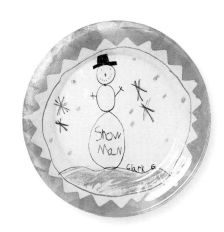

Decoupage with children's art—
on glass or on wood—makes a
rewarding treasure for a family.

Glass snowman plate
SUPPLIES Clear glass dessert plate, tissue paper torn into quarter-size pieces, sponge brush, Provo Craft jumbo pinking scissors, Mod Podge decoupage glue, picture drawn or copied onto lightweight white paper. **INSTRUCTIONS** Cut a circle slightly larger than bottom of plate with art at center. Apply glue to both sides of picture. Place face down on back of plate. Smooth out any air bubbles. Brush glue on torn pieces of tissue paper and add to plate until back is covered. Put plate upside-down on raised surface to dry overnight. Trim any paper hanging over plate edge with razor blade. Note: Handwash only. Do not soak in water.

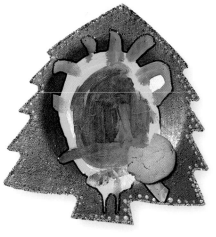

Green Christmas tree plate
SUPPLIES Multi-Ply wood plate, Lumiere Pearl Emerald Green and Metallic Gold paint, sponge brush, Mod Podge Gloss, Krylon 18 kt. Gold Leafing Pen, Stickles Gold Glitter Glue, Jazz Beadazzles-Suze Weinberg Copper and Gold Beads, Black Pigment Marker, Gold Pearl Dimensional Paint, art. **INSTRUCTIONS** Paint plate green, then glaze lightly with gold. Photocopy and reduce art, glue with Mod Podge. Trace edge of art with pen. Apply glitter glue to top edge and sprinkle with beads. Squeeze droplets of dimensional paint around perimeter.

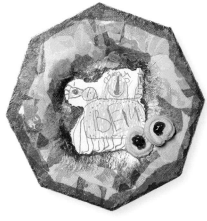

Octagonal plate
SUPPLIES Multi-Ply wood plate, Lumiere Pearl White, Metallic Gold, and Pearl Blue paint, Mod Podge, sponge brush, blue and green tissue paper, yellow and gold paper napkin, art (continued on p. 56).

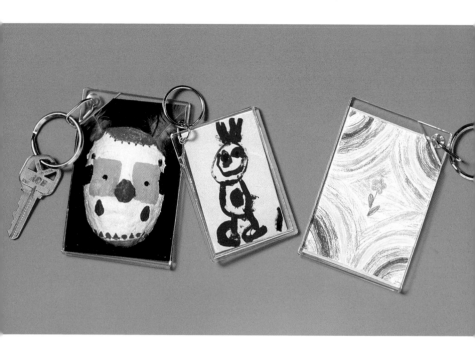

The clear plastic photo key chains available in craft stores are novel vehicles for displaying children's art. Combine the art with a photo of the child, a favorite verse, or an art sample from another child. If the art's dimensions don't match those of the key chain, try framing the art with color cardstock. These make great stocking-stuffers at Christmas or fun take-homes when left at each plate during a holiday party.

Mask with feathers
SUPPLIES Clear plastic photo key chain, adhesive, photo of three-dimensional art, complementary photo (not shown). **INSTRUCTIONS** Crop both photos to fit plastic case, making diagonal cut at corner nearest hole for key. Glue photos together and insert both photos in plastic case.

Little boy blue
SUPPLIES Clear plastic photo key chain, photo of art. **INSTRUCTIONS** Crop photo to fit plastic case and insert.

Pink flower
SUPPLIES Clear plastic photo key chain, color copy of art. **INSTRUCTIONS** Reduce color copy of art as needed to fit into plastic case. Make diagonal cut at corner nearest hole for key. Insert copy of art into plastic case.

Computer Mouse Pad

You'll think about your child every time you click on a special mouse pad custom-designed to display her artwork. The mom who made this one scanned the art and used her computer to size it to fit this mouse pad's pull-back plastic window, but you can just as easily make a color copy or even insert original art. This makes a great gift for a hard working, computer-driven parent and a nice addition to the family work space. Some companies will make printed fabric mouse pads from children's art as school or church fundraisers.

SUPPLIES Mouse pad made by Neil Enterprises, Hewlett-Packard ScanJet 4200C, Microsoft Word software, art. **INSTRUCTIONS** Scan artwork using the ScanJet. Save in Microsoft Word. Measure the pull-back clear plastic window in the mouse pad and re-size the art appropriately. Print, trim, and place in mouse pad.

Pencil Holders

Abstract works of art from young children can be as decorative as wallpaper or fabric designs. Work with a color copy of the original to avoid hurt feelings when you trim art to fit around the can. Or, photograph the art and let it inspire you to make it part of your own collage. For gift giving, make a set of useful desktop items—checkbook cover, mouse pad, pencil holder—from related or the same piece of art.

Paint splatter paintbrush holder
SUPPLIES Can, lid, craft knife, photo mounts, copy of art. **INSTRUCTIONS** Trim copy of art to height of can. Secure with photo mounts. Cut small "x" shapes in lid with knife.

All heart pencil holder
SUPPLIES Can, Me and My Big Ideas sticker border, cardstock, adhesive, photos of Valentines. **INSTRUCTIONS** Cover can with cardstock and decorate.

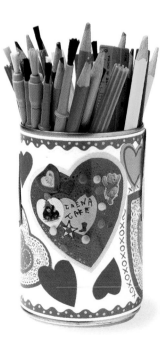

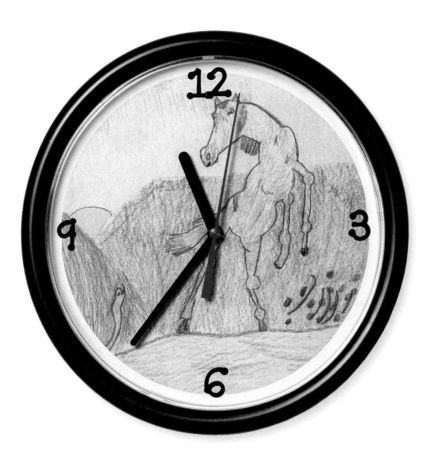

D isplaying art in a clock is easier than it looks! Some computer programs include a clock face template, or you can purchase a kit from a company such as Chimeric and they will make the clock for you. Copy your art, crop it to the appropriate size, send it in as directed in the kit, and a few weeks later a finished clock arrives in the mail.

SUPPLIES Neil Enterprises blank clock, Provo Craft number stickers, Hewlett-Packard ScanJet 4200C, Microsoft Word software, Fiskars circle cutter, art.
INSTRUCTIONS Scan art. Save in Word. Print art and trim to an 8" diameter circle using circle cutter. Apply number stickers. Insert in clock according to instructions.

Memory Game

se a series of your child's artful images to create a one-of-a-kind memory game. Stick to a single theme for a unified look. Use a sharp knife when cutting foam-core squares.

The sample above uses art, but you can also use extra copies of school photos for a variation. Yet another version can be created by saving lots of circular metal lids from frozen juice containers. Use a circle cutter to cut out duplicate color copies of kid's designs in a slightly smaller size than the lid; mount the pictures on lids with craft glue.

Another variation is to make a spelling game. Have your child copy the letters of the alphabet on a piece of paper, then cut around each individual letter and mount the letter on a juice-can lid or on a square of foam core covered with colored cardstock.

SUPPLIES Foam core or heavy cardstock, scissors or craft knife, adhesive, reduced color copies of original art. **INSTRUCTIONS** Make two copies of art on color copier, reducing as necessary. Mount images on foam core and cut out with craft knife.

Jigsaw Puzzle

Create your own custom-designed jigsaw puzzle by using a favorite work of art. A large, simple image works best for younger children; a more detailed image will hold the attention of older ones.

SUPPLIES Coluzzle™ EZ Glide cutting mat, swivel knife, rectangle puzzle template, sticky puzzle backing, sharp scissors, color copy of artwork. **INSTRUCTIONS** Pull sticky backing from puzzle mat and smooth color copy onto mat. Place puzzle mat on EZ-glide cutting mat. Center puzzle template on top of color copy. Place swivel knife into the cutting channel (holding knife straight up and down). While pressing firmly onto the template with your non-cutting hand, begin pulling the swivel knife. Be careful not to move the template. When all channels have been cut, trim webs (small connections in the template that hold it together) with straight side of knife.

IDEA TO NOTE: When using the Coluzzle™ templates, it's extremely helpful to remember not to curve your wrist to drive the knife. Pull with your elbow, like you're shifting gears in a car, and keep your wrist straight. Let the swivel knife do all the cutting.

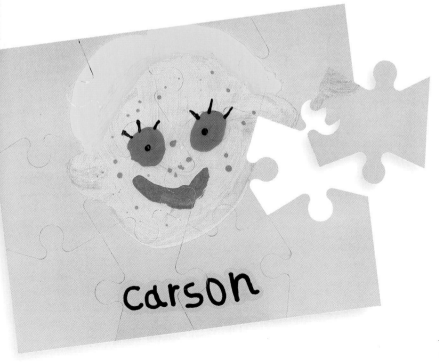

Sweatshirt

Keep loved ones warm in a sweatshirt designed especially for them. Select buttons and decorative pins to coordinate with art. A witty message can complement the design. White works best; gray and other colors can interfere with the way the image transfers to the fabric. Be sure size is large enough for the wearer and prewash to prevent shrinkage.

Cat-titude sweatshirt

SUPPLIES Sweatshirt from craft store, HP Iron-On T-shirt Transfers, Hewlett-Packard ScanJet 4200C, Microsoft Word software, decorative buttons to match theme, iron, cat drawing. **INSTRUCTIONS** Scan artwork. Save in Word. Size art to fit on front of sweatshirt. Insert text box for "Cat-titude" on the top and "is everything" on the bottom. Print and apply to sweatshirt according to transfer paper instructions. Sew on buttons.

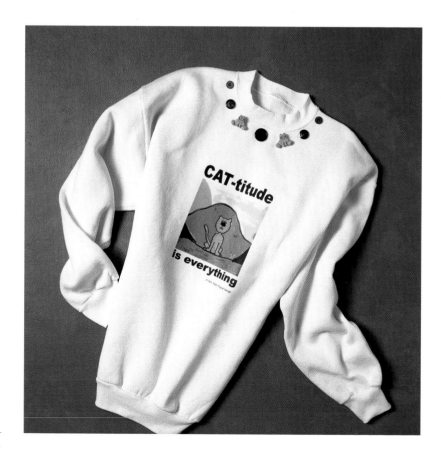

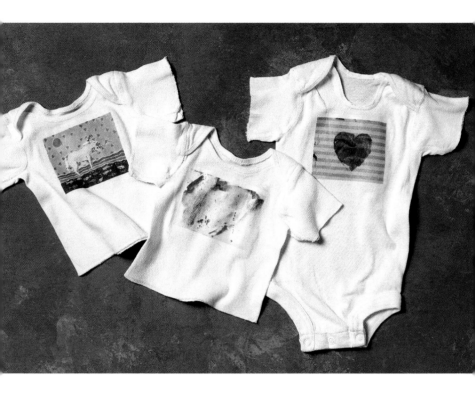

Have siblings, cousins, or family friends choose a favorite piece of art to create a personalized welcoming gift for baby! Once it's outgrown, preserve the garment (with a photo of baby wearing it) in a shadow box as a family keepsake. Some transfer papers are easier to use than others. Read directions carefully before buying. Fabric texture affects the quality of the transfer. The kind of cotton used in most 100% cotton baby T-shirts takes a clean transfer.

If you don't have a color printer, buy transfer paper that can be used with a copy shop's color copier (see Martingale in resource list).

Baby T-shirts
SUPPLIES 100% white cotton T-shirt/ Onesie, Avery T-shirt transfer paper, Epson Stylus photo 700 ink jet printer, Scan Ace scanner, Mac Performa 6200 CD, Claris works program for artwork, iron, art.
INSTRUCTIONS Scan and size artwork to fit garment. Follow directions for transfer to garment.

Apron

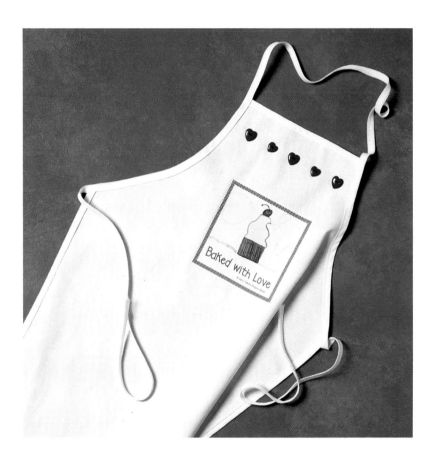

Grandma would be tickled pink to receive this homemade "Baked with Love" apron. Pin a favorite cookie recipe to the front and get her busy with some young helpers! Add buttons for a decorative touch, and include child's name as the designer. If you don't have a color printer, buy transfer paper that can be used with a copy shop's color copier.

SUPPLIES Apron from craft store, HP Iron-On T-shirt Transfers, buttons to match theme, Hewlett-Packard ScanJet 4200C, Microsoft Word software, font Page Printables Doodle Tipsy from Cock-A-Doodle Design, iron, original art. **INSTRUCTIONS** Scan artwork. Save in Word. Re-size artwork to fit on front of apron. Insert text box for "Baked with Love." Select Insert: Picture: AutoShape to add frame. Print and apply to apron according to transfer instructions. Sew on buttons.

Save a year's worth of your children's art or gather up artwork from all the grandchildren and create a family quilt—a treasured keepsake or a wall hanging. The owl quilt square was based on a child's construction-paper collage. The fabric pieces correspond to the paper pieces of the original. Art can also be made into quilts with photo transfer paper. See *Quilting Your Memories* (Resources) for ideas.

SUPPLIES Fusable bonding, scissors, iron, fabric, several color copies of artwork. **INSTRUCTIONS** Cut figures from artwork and use as patterns. Copy backwards onto fusable bonding and cut around figure leaving wide margin. Iron bonding to back of fabric, trim, remove backing, arrange on background, and iron.

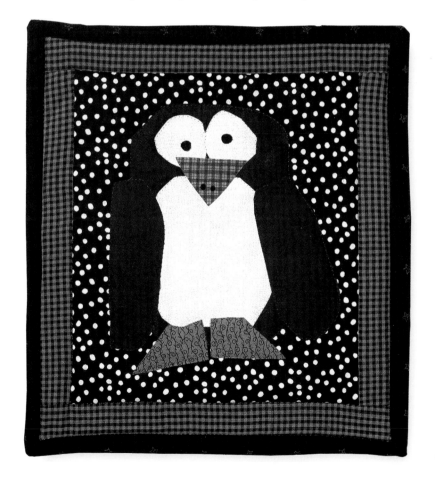

STATIONERY

Make your own greeting cards using your child's art. Use color copies, photographs, or computer scans depending on the effect you want to create.

Making Cards From Scratch

- Start from the envelope size. Card-size envelopes come in dimensions of 6 x 9", 5 x 7", and 4 x 6". Cut your cardstock to fit. The best bet: buy envelopes first, then plan your cards. Choose paper that coordinates with the art in both color and mood. Stick to simple, solid colors so art remains the highlight.
- Use acid-free paper for cards and notes that you want to preserve. You may not need gift tags to last as long as birth announcements.
- 100% cotton paper does not mean it is acid-free.

Using Premade Card-and-Envelope Sets

- Purchase blank cards and matching envelopes. Simply copy and reduce art or trim photo to fit.

Taking Photos of Art

- Photographs are easy to use for cardmaking because they make art of any dimension exactly the right size for your purpose.
- When taking a picture of art, simplify the background so there are no distractions. Use sheets of solid scrapbooking paper, a large unwrinkled piece of fabric, or other non-reflective surface.

SUPPLIES Red premade card and envelope, coordinating paper, photo mounts or other adhesive, color copy.

- Avoid using a flash because it creates shadows. Shoot outside, or use natural light from a window if possible. Get as close to your subject as your camera manual says you can. Keep the camera steady by propping your elbows against your body so there'll be no movement. Even the smallest shake will cause a blurry picture. Develop into 4 x 6" or 5 x 7" prints to allow for cropping.
- Using a black background when photographing a piece of art made on light paper helps it stand out.
- Take two pictures of the art, one a little closer than the other. Use the larger image on the card, the smaller one to seal the envelope.
- Make multiple copies for use in a set of greeting cards.

Scanning Art for Greeting Cards and Envelopes

- Use different images from the same art to make stationery and envelopes.
- Most computer programs will help you create fun messages inside.

Using a Color Copier

- Reduce the art until it's very small and make return address labels that match the artwork you have displayed on your notecards and stationery.
- Make multiple color copies of art for a whole batch of seasonal or holiday gift tags.
- You can use a color copier to

Turtle: **SUPPLIES** Noteworthy premade card and envelope, color cardstock, photo mounts, photo of artwork.
Splatter heart: **SUPPLIES** Double heart card with envelope (Stampendous!), photo mounts, color copy of artwork.

make wrapping paper out of the simplest art. Repeat designs work especially well.
- Copy a strongly vertical piece of art to make a bookmark.

Personalizing greetings with home-made images and messages is a wonderful way of letting friends and family know how much they mean to you and your children.

Unique cards are a snap to make with scrapbooking supplies. Layering papers, matting photos, drawing simple borders, and using creative lettering are easy scrapbook techniques that result in awe-inspiring greetings!

Red hand

SUPPLIES Red and white cardstock, patterned paper, photo mounts, photo. **INSTRUCTIONS** Fold white cardstock and trim into 5" square card. Trim photo into small square. Mount onto a slightly larger square of red cardstock. Cut red cardstock to fit exactly on front of blank card. Secure with photo mounts. Trim patterned paper slightly smaller than card and secure to front, leaving narrow border of red. Mount bordered photo on front of card, centering carefully.

Thanks

SUPPLIES White and color cardstock, pen, photo mounts, black surface for background, yellow cardstock. Black envelope: label with pink and yellow cardstock. **INSTRUCTIONS** Create lettering on white cardstock proportionate to art. Cut letters into squares, mount on larger squares of color cardstock. Position on background under art. Trim photo, mount on front of yellow card.

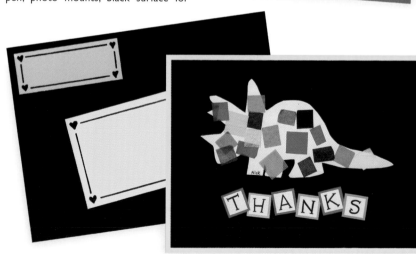

Photos and Existing Stationery

Taking photos of your child's art will make it the right size to use on cards. Add ready-made stationery and contrasting cardstock for matting and you've got a great-looking card.

Blue flower

SUPPLIES 5" square premade white card and envelope, blue cardstock, photo mounts, photos of art at different distances. **INSTRUCTIONS** Trim photo with larger image to fit on front of card. Mount on larger square of white cardstock. Cut blue cardstock same size as card and secure. Mount photo and mat on blue. For envelope, trim photo with smaller image to approximately 2 x 2", mat with blue paper, and secure.

Red hearts

SUPPLIES White premade card and envelope, red cardstock, photo mounts, photo. **INSTRUCTIONS** Trim photo so it fits within a 1" border of card. Tear red cardstock into rectangle slightly larger

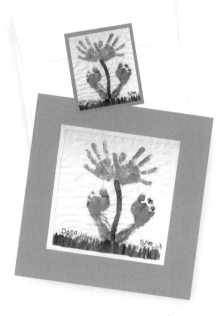

than photo. Mount photo onto red rectangle and rectangle onto card.

Arizona flag

SUPPLIES White premade card and envelope, color cardstock, photo mounts, photo. **INSTRUCTIONS** Trim photo if necessary. Mat. Secure with photo mounts.

Cards and Their Messages

Personalize your homemade cards even further by adding a clever line or warm sentiment on the inside.

Easter bunny card

SUPPLIES Noteworthy 5" square blank card and envelope, blue, yellow, and white cardstock, photo mounts, art. **INSTRUCTIONS** Make color copy of art, reducing if necessary. Cover front of card with blue paper. Crop art leaving equal borders on all sides. Secure layers. Pen message on white cardstock and trim into rectangle. Make large and small blue mats, torn-paper yellow mat. Secure all layers.

Pink fairy card

SUPPLIES Noteworthy 5" square blank card and envelope, pink cardstock, vellum, photo mounts, spray adhesive, small hole punch, fancy ribbon. **INSTRUCTIONS** Copy a black-and-white sketch on pink paper, trim to fit and secure to front of card. Cut 5" square of vellum. Secure over inside message. Punch two holes on front edge of card. Thread ribbon and tie bow.

Photo Frame Cards

Ready-made frame cards convey a dimension of formality—even elegance—to cards you make with photos or color copies of children's artwork.

Face frame card
SUPPLIES Kolo blank card with die-cut window and matching envelope, photo mounts, photo. **INSTRUCTIONS** Crop photo and mount on the inside of card, making sure it's centered in window.

Joy to the World frame
SUPPLIES Christmas photo frame, photo mounts, photo of three-dimensional craft project with picture of child. **INSTRUCTIONS** Trim photo and secure inside card with photo mounts.

Unicorn in red frame
SUPPLIES Photo frame card and envelope, red cardstock, photo mounts, art. **INSTRUCTIONS** Copy art on color copier, reducing as necessary. Cover border of card with red cardstock, leaving a narrow, white border on inside edge of die-cut window. Mount in frame card.

A Set of Cards

When your child (or children) produces a series of art projects with the same or similar themes, think about making a set of cards out of all the variations. This can be done while your child is in a phase of drawing princesses, ships, zoo animals, birds, planets, or with any project your kids get involved in together. A variation on a common theme is perfect material for a set of notecards for your own use, or to give as a gift.

To photograph artwork, it's easiest to use a point and shoot camera. Stand as close to the artwork as the camera allows and shoot. If your automatic camera prevents you from shooting at too close a range, experiment. Get a bit too close, then back gradually away from the artwork until the camera allows you to take the picture. Shoot all photos for pictures in a series during the same session so background color and lighting will be uniform. If the resulting photos aren't the correct size they can be enlarged or reduced on a color copier.

SUPPLIES Personal Stamp Exchange notecards and matching envelopes, photo mounts, photos. **INSTRUCTIONS** Trim photos to fit exactly in indented rectangle. Secure with photo mounts.

Use premade corrugated paper cards to display photos of your kid's art for an eye-catching look. Bright white borders accent the art, color mats soften the overall look.

Sun

SUPPLIES Paper Reflections card with envelope, color cardstock, photo mounts, photo of art. **INSTRUCTIONS** Trim excess background from photo. Mount on cardstock and trim to create narrow border. Create second border with torn cardstock and mount on card.

Snowman

SUPPLIES Same as Sun. **INSTRUCTIONS** Same as Sun but eliminate second border.

Native American

SUPPLIES Same as Sun. **INSTRUCTIONS** Same as Sun but eliminate second border and add raffia accent.

Rhino

SUPPLIES Same as Sun. **INSTRUCTIONS** Same as Snowman.

U se color copies of an original piece of art to create one-of-a-kind greeting cards.

Pink card with sailboat

SUPPLIES Blank pink card with matching envelope, photo mounts, color copy of art. **INSTRUCTIONS** Reduce art on color copier. Trim so that borders between art and card are equal on all sides. Secure copy to card.

Flower collage card

SUPPLIES Cream and brown cardstock, photo mounts, color copy of art. **INSTRUCTIONS** Fold and trim cream cardstock so it fits in a no. 10 envelope (regular business envelope). Cover front of card with brown paper. Crop color copy of art so there is an equal border on all four sides. Secure layers with photo mounts.

Heart color copy card

SUPPLIES Blank card with matching envelope, red cardstock, photo mounts, art. **INSTRUCTIONS** Reduce art on color copier. Trim so that borders between art and card are equal on all sides. Mount on cardstock; trim. Secure layers to card.

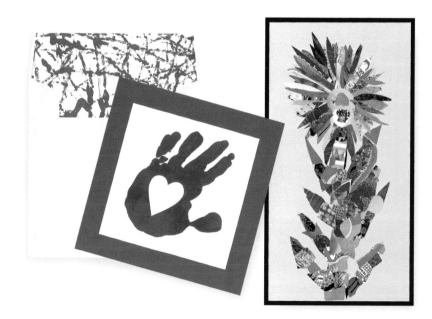

Take advantage of the wonderful assortment of software available today to create your own personalized greeting cards. Follow the specific instructions that came with your software and equipment.

Christmas card

SUPPLIES White cardstock, glue stick, art. **EQUIPMENT** Hewlett-Packard ScanJet 4200C. **SOFTWARE** Page Printables CD by Cock-A-Doodle Design, font Doodle Crayon, Microsoft Greetings Workshop. **INSTRUCTIONS** Scan artwork. Size picture to fit on front of card. Using WordArt, type "Merry Christmas" and choose the half-circle shape. Place in the appropriate spot and print. In Microsoft Greetings Workshop, create a card, leaving the front page blank. On the inside, type your greeting. On the back, credit the artist. Print and fold, matching up edges carefully. Secure picture to front of card.

From our house to yours

SUPPLIES Pre-scored notecard for printer, glue stick, art. **EQUIPMENT** Hewlett-Packard ScanJet 4200C. **SOFTWARE** Page Printables CD by Cock-A-Doodle Design, font Doodle Crayon. **INSTRUCTIONS** Size and place artwork on the bottom half of the document. Insert a text box above the art and type message. Print and fold in half.

CARDS GIFT TAGS INVITATIONS: STATIONERY

77

Announcements

Make your good news even more special by using your children's creations in your announcements.

New phone number announcement
SUPPLIES Red and white cardstock, photo mounts, art. **INSTRUCTIONS** Trim and mount art on red cardstock. Write message on white paper proportionate to art. Cut into rectangle. Mount on red cardstock. Copy.

Birth announcement
SUPPLIES Kolo blank card and envelope, beige recycled paper, photo mounts, art. **INSTRUCTIONS** Copy art on beige paper, reducing to fit inside die-cut window. Trim to fit inside card and mount.

Matching return address labels
SUPPLIES Beige recycled paper, white paper. **INSTRUCTIONS** Write baby's name and address on regular paper. Add art and reduce onto regular paper. Copy onto beige paper. Copy, trim, and glue.

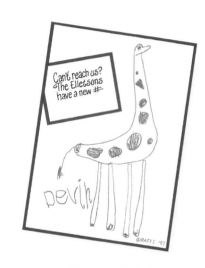

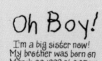

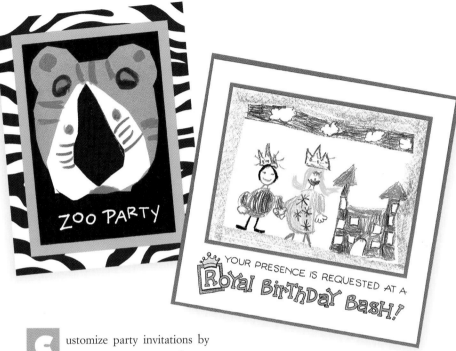

Customize party invitations by creating your own theme-based cards from kids' drawings. Inside the card or on a postcard backing, include the child's name as well as date, time, place, and phone number for RSVPs.

Zoo party

SUPPLIES Zebra stripe patterned paper, envelopes (optional), black, white, and peach cardstock, adhesive, White Writer Sailor pen, art. **INSTRUCTIONS** Copy art on color copier. Reduce or enlarge as necessary. Cut out tiger design. Mount on black paper. Mount this on slightly larger rectangle of peach cardstock, creating narrow border. Cut a larger rectangle out of patterned zebra paper so border is larger than the peach border. Write message in black space at bottom. Make copies on a color copier, reducing or enlarging as necessary.

Royal Birthday Bash

SUPPLIES Color cardstock, photo mounts, pen by Sakura, colored pencils by Prismacolor, art. **INSTRUCTIONS** Color copy art, reducing or enlarging as necessary. Trim excess background. Mount on cardstock and trim to create narrow border. Prepare letters on paper using lined paper and light box, copy onto textured paper and color in with pencils. Mount art above lettering. Trim paper to correct size.

Postcards

All you have to do to make your own postcard is to mount a photo, color copy, or color printout of your child's art on sturdy cardstock, securing the corners and edges of the art so they won't catch during mail processing. To qualify for the special postcard rate, your postcard has to be a maximum of 4½ x 6" and a minimum of 3½ x 5", no thicker than ¼", and no heavier than 1 oz. Other dimensions or weights require first-class postage—or more. Check with the post office.

Rainbow postcard
SUPPLIES Black and magenta cardstock, adhesive, photo of art.

Clown postcard
SUPPLIES Kraft color cardstock, adhesive, photo of art.

Woven postcard
SUPPLIES Pink and yellow cardstock, adhesive, photo of art.

> **IDEA TO NOTE:** Use an acid-free backing such as PhotoPostos self-adhesive postcard labels, which are exactly 4 x 6," to remind you of the correct size and to add an authentic look.
>
>

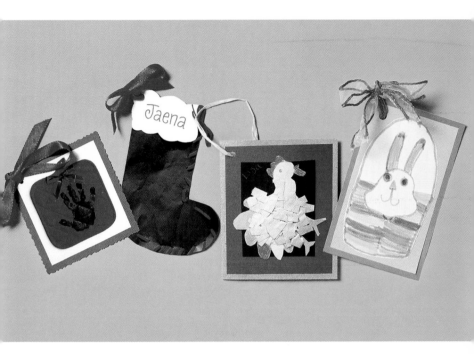

ttach homemade gift tags to a present. Write the "to" and "from" information on the back, or mount art on a homemade folded card. Use raffia, twine, chenille sticks, yarn, colored ribbon, or embroidery floss that complement the art.

Potholder

SUPPLIES Cardstock, photo mounts, small hole punch, ribbon, photo of art.
INSTRUCTIONS Crop photo, mount on cardstock. Punch hole. Attach ribbon.

Stocking

SUPPLIES Cardstock, photo mounts, small hole punch, ribbon, photo of art.
INSTRUCTIONS Mount art on cardstock, trim to desired shape. Punch hole. Attach ribbon.

Chicken

SUPPLIES Cardstock, photo mounts, small hole punch, raffia, photo of art.
INSTRUCTIONS Trim photo to desired shape. Mount on cardstock leaving small border. Punch hole. Attach raffia.

Bunny

SUPPLIES Cardstock, glue pen, small hole punch, ribbon, color copy of art.
INSTRUCTIONS Mount art on cardstock, creating a narrow border. Punch hole. Attach ribbon.

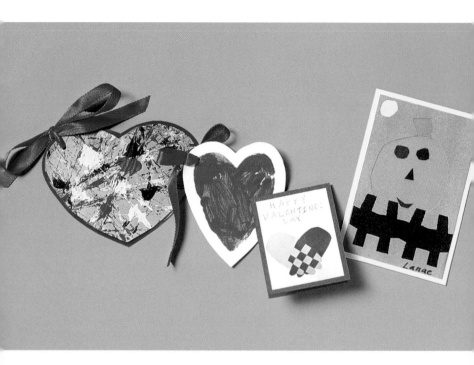

So much of the art children make at school is seasonal. By creating your own gift tags you can reuse the images and share your child's creativity with gift recipients. Cut tags into fun shapes and add a clever message on the back. Or make your own folding card and attach to the gift with a photo mount.

Splatter-art heart
SUPPLIES Red cardstock, glue pen, small hole punch, ribbon, photo of art. **INSTRUCTIONS** Mount photo on stock and cut in heart shape. Punch hole and thread ribbon.

Solid stenciled heart
SUPPLIES Textured cardstock, small hole punch, ribbon. **INSTRUCTIONS** Have child paint heart on stock and cut in heart shape. Punch hole and thread ribbon.

Woven hands heart
SUPPLIES Red cardstock, glue pen, photo of art. **INSTRUCTIONS** Score and fold cardstock. Glue photo, leaving small border of red.

Pumpkin
SUPPLIES Yellow cardstock, glue pen, color copy of art. **INSTRUCTIONS** Score and fold cardstock. Mount art, leaving small border of yellow around picture.

Making gift tags from art for parties and special occasions is as much fun as creating the art itself! Trim your tags with a chenille stick or ribbon. Make your own folded card with cardstock.

A New House
SUPPLIES Cardstock, photo mounts, photo of art. **INSTRUCTIONS** Score and fold cardstock. Trim photo to fit card, leaving small border. Mount photo on card.

Clown
SUPPLIES Cardstock, small hole punch, chenille stick, glue, photo of art. **INSTRUCTIONS** Glue photo on cardstock and cut around to create die-cut shape. Punch hole. Thread chenille stick.

Sunshine gift enclosure
SUPPLIES Cardstock, photo mounts, color copy of art. **INSTRUCTIONS** Score and fold cardstock. Trim photo, leaving small border. Mount on cardstock.

Ice Cream Cone
SUPPLIES Cardstock, small hole punch, ribbon, glue pen, photo of art. **INSTRUCTIONS** Score and fold card. Cut out shape. Glue on card. Punch hole.

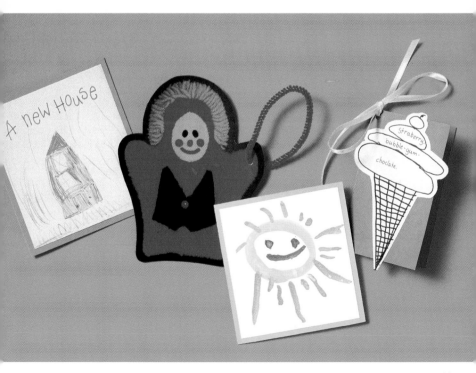

You'll be adding a gift of your child's art whenever you present gifts in homemade wrapping paper or gift bags. Select simple art, or art that forms a regular pattern, for best results. Bound to be a favorite with grandparents!

Red gift bag

SUPPLIES Gift bag of coordinating color, glue stick, color copy of art. **INSTRUCTIONS** Reduce copy of art to fit on front of gift bag. Glue art on bag. Decorate one or both sides.

Ladybug gift box

SUPPLIES 4" cubic kraft gift box, green cardstock, decorative scissors, photo mounts, ladybug art. **INSTRUCTIONS** Trim five squares of green cardstock with decorative scissors to just under 4". Make five color copies of ladybug art and mount on cardstock. Mount cardstock on box.

Emmy's paper

SUPPLIES Bow, color copy of art. **INSTRUCTIONS** Enlarge art onto 11 x 17" paper, if necessary, and wrap present.

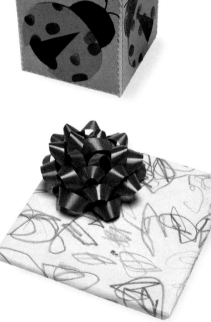

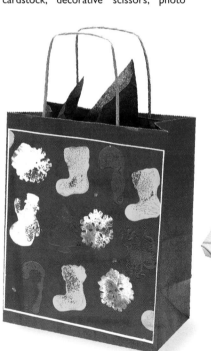

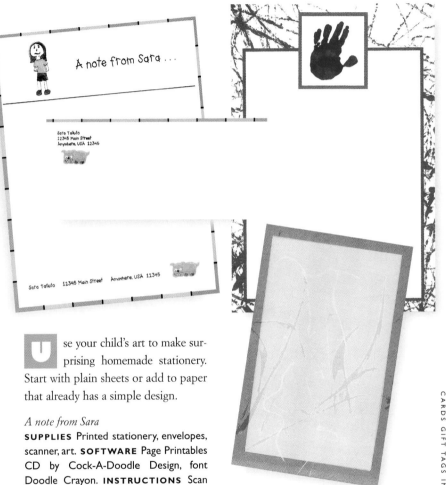

Use your child's art to make surprising homemade stationery. Start with plain sheets or add to paper that already has a simple design.

A note from Sara

SUPPLIES Printed stationery, envelopes, scanner, art. **SOFTWARE** Page Printables CD by Cock-A-Doodle Design, font Doodle Crayon. **INSTRUCTIONS** Scan artwork. Save in Word. Size images to fit desired positions on page. Insert text boxes for messages and addresses. For envelopes, scan artwork. Save in Word.

Handprint stationery

SUPPLIES Cardstock, copies of handprint and art. **INSTRUCTIONS** Mount copy of handprint on red cardstock. Mount rectangle of white cardstock on red cardstock. Mount all on copy of background art. Print via scanner or copier.

Fade-center stationery

SUPPLIES Vellum, art. **INSTRUCTIONS** Crop two sheets of vellum leaving border around art of 1". Place art on top. Copy.

CARDS GIFT TAGS INVITATIONS: STATIONERY

85

Memo Pads

Memo pads using your child's art are easy to make, fun to have around the house, and can be personalized for gift giving. Combine art with a child's handwritten message for a clever effect. Choose from a variety of papers available in stationery and craft stores. Many copy shops can make the art into memo pads of various sizes. Copy centers will copy, cut, and do notepad binding relatively inexpensively. They can also put cardboard on the back to make a sturdier pad.

Simple line art drawn with pen and ink works best and, because you're making lots of copies, will be much more affordable than a project using color copies on each page.

Don't forget to do
SUPPLIES Lined paper, tan recycled paper, photo mounts, pencil drawing. **INSTRUCTIONS** Copy art on black-and-white copier (line drawings work best), reducing or enlarging as necessary. Mount on the lined paper. Copy onto tan paper.

Ubu and Cowboy
SUPPLIES White paper, bright paper, scissors, paper cutter, adhesive, pencil drawing. **INSTRUCTIONS** Fold 8½ x 11" sheet of white paper into four vertical rectangles. Make four reduced copies of drawing on regular copier, cut out, and place one in upper left corner of each rectangle. Copy on bright paper and cut into fourths, or give copy shop the four-up master for copying and binding.

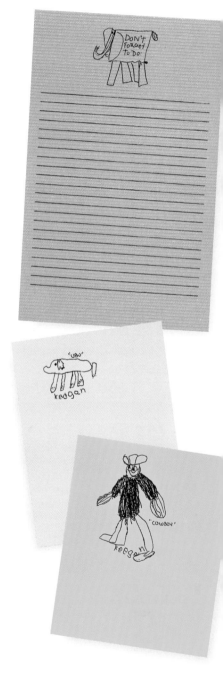

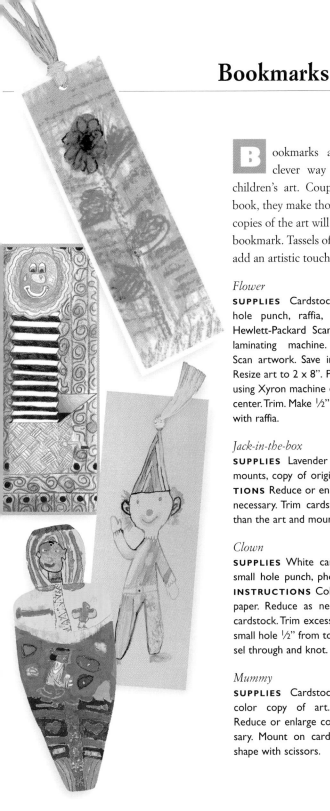

Bookmarks

Bookmarks are an easy and clever way to display your children's art. Coupled with a good book, they make thoughtful gifts. Two copies of the art will make a reversible bookmark. Tassels of silk cord or raffia add an artistic touch.

Flower

SUPPLIES Cardstock, adhesive, small hole punch, raffia, art. **EQUIPMENT** Hewlett-Packard ScanJet 4200C. Xyron laminating machine. **INSTRUCTIONS** Scan artwork. Save in Microsoft Word. Resize art to 2 x 8". Print. Laminate page using Xyron machine or laminate at copy center. Trim. Make ½" hole in top and tie with raffia.

Jack-in-the-box

SUPPLIES Lavender cardstock, photo-mounts, copy of original art. **INSTRUCTIONS** Reduce or enlarge copy of art as necessary. Trim cardstock slightly larger than the art and mount art.

Clown

SUPPLIES White cardstock, tan paper, small hole punch, photo mounts, tassel. **INSTRUCTIONS** Color copy art on tan paper. Reduce as necessary. Mount on cardstock. Trim excess background. Make small hole ½" from top edge. Thread tassel through and knot.

Mummy

SUPPLIES Cardstock, photo mounts, color copy of art. **INSTRUCTIONS** Reduce or enlarge copy of art as necessary. Mount on cardstock. Cut around shape with scissors.

CARDS GIFT TAGS INVITATIONS: STATIONERY

87

alendars are a perfect way of putting your children's art to use, since kids seem to love making seasonal pictures. Have children select their favorites. Make two calendars, one for home and one to give as a gift!

April

SUPPLIES 12 color copies of art, 24 pieces colored cardstock, 12 sheets cardstock to coordinate with art, calendar sheets (home-made using computer-generated grid), glue stick. **INSTRUCTIONS** Trim artwork to fit on cardstock, leaving 1" border. Trim calendar page smaller than cardstock and mount, leaving border on each side.

January

SUPPLIES 12 color copies of art, 24 pieces white cardstock, 12 sheets cardstock to coordinate with art, calendar sheets (available from craft/stationery stores or print from computer program) decorative-edged scissors, glue stick. **INSTRUCTIONS** Trim artwork to fit on 8½ x 11" cardstock. Glue to cardstock. Trim calendar sheet with decorative scissors, mount on cardstock cut smaller than 8½ x 11". Mount on white 8½ x 11" cardstock.

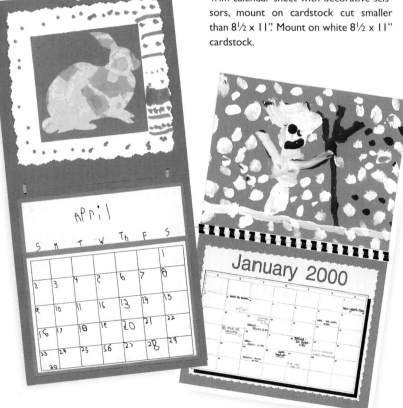

Resources

GENERAL SUPPLIERS

Many suppliers on this list are whole-salers but will direct you to stores in your area that carry their products.

Alto's EZ Mat, Inc.
Matting tools and supplies; excellent matting instructions on website.
703 N. Wenas
Ellensburg, WA 98926
800/225-2497
509/962-9212
509/962-3127 (fax)
www.altosezmat.com

Art Hang-Ups from Valley Circle Products
Nylon display rope and colorful plas-tic clothespins in two sizes.
22647 Ventura Blvd. #531
Woodland Hills, CA 91364
818/224-3069
818/224-3006 (fax)
Ron@valleycircle.com

Bajer Design & Marketing, Inc.
Stuffed animal chain that can be hung horizontally (instead of verti-cally) to display art.
20875 Enterprise Avenue
Brookfield, WI 53045
262/796-1776

Books by Hand
Easy kits include pre-cut materials, binding cloth, and beautiful papers for making accordion books, albums, and picture frames.
P.O. Box 80354
Albuquerque, NM 87198
505/255-3534
505/255-3634

Fridge Frame, Inc.
Display-It magnetic display system: organize art like a collage under protective film, display on the refrigerator.
P.O. Box 25204
3616 Bailey Ridge Circle
St. Paul, MN 55125
651/730-0083
651/730-0798
www.display-it.com

Joshua Meier Company, Inc.
Spel-Binder display easel: store like a scrapbook or open to display one page at a time.
777 Terrace Avenue
Hasbrouck Heights, NJ 07604
800/526-7131

Kolo
Small specialty albums, photo frame cards, and accordion books.
241 Asylum Street
Hartford, CT 06103
860/547-0367
www.kolo-usa.com

The Magnet Source

Master Magnetics/self-adhesive magnet sheeting can be cut to fit any size project.
607 S. Gilbert Street
Castle Rock, CO 80104
888/293-9190
303/688-3966
303/688-5303 (fax)
www.magnetsource.com

Martingale & Company

Photo transfer paper for use on color copiers; quilting books.
P.O. Box 118
Bothell, WA 98041
800/426-3126
www.patchwork.com

MCS Industries, Inc.

Fridge Frame 9 x 12" Plexiglas magnetic frame.
2280 Newlins Mill Road
Easton, PA 18045
610/253-6268

Multi-Ply Wood Design

Unfinished wooden plates and trays for decoupage.
46 Grey Street
Fredericton, NB
Canada E3B 1V7
800/550-2325
506/367-5283
www.multi-ply.com

Neil Enterprises, Inc.

Key chains, mugs, mouse pads, clocks into which copies of children's art can be inserted.

450 E. Bunker Ct.
Vernon Hills, IL 60061
847/549-7627
847/549-0349 (fax)
www.neilenterprises.com

PhotoPostos

Self-adhesive acid-free postcard backing.
132 Garden Street, Suite 3
Santa Barbara, CA 93101
888/665-3736
805/882-1841
805/882-1842 (fax)
www.photopostos.com

Rubber Stampede, Inc.

Large rubber stamps and stamping accessories for home decor and paper projects.
967 Stanford Avenue
Oakland, CA 94608
510/420-6845
510/420-6888 (fax)

Wallies

Wallpaper cutouts.
P.O. Box 210
Belmont, VT 05730
800/255-2762 ext. 373
802/492-3450 (fax)
www.wallies.com

Xyron Inc.

Magnet and adhesive machines.
15820 North 84th Street
Scottsdale, AZ 85260
800/793-3523
480/443-9419
480/443-0118 (fax)

ARCHIVAL SUPPLIES

Archival Image
Plastic sleeves, presentation materials, and professional photography supplies.
800/688-2485

Gaylord Bros.
Storage binders, boxes, and acid-free tissue.
800/634-6307

Metal Edge
Acid-free boxes, storage supplies, binders, papers.
800/862-2228

Preservation Source
Supplies for preserving paper documents, photographs, and textiles.
801/278-7880

University Products, Inc.
Boxes, furniture, tools, papers, acid-free tissue, and books.
800/628-1912

COMPANIES THAT TRANSFER CHILDREN'S ART ONTO HOUSEHOLD OBJECTS

Chimeric, Inc.
Books, clocks, and watches.
1500 West Hampden Avenue, #3-B
Englewood, CO 80110
303/762-7888
303/762-7886 (fax)

Kid Art from Code 3 Grafx
Mugs, mouse pads, key chains, calendars, puzzles, clothing, clocks, and more, useful for school fundraising events.
331-N Glendare Court
Winston Salem, NC 27104
336/659-0303
336/659-0053 (fax)
www.code3grafx.com/kidart

Leisure Arts Stitch-A-Photo
Cross-stitch patterns.
P.O. Box 5710
Little Rock, AR 72215
800/643-8030 ext. 259
www.stitchaphoto.com

Original Works
Make art into products as diverse as mugs and key chains, T-shirts and hats.
54 Caldwell Road
Stillwater, NY 12170
518/584-9278
800/421-0020
www.originalworks.com

BOOKS AND COMPUTER SOFTWARE

The Best of Creative Lettering CD, Volumes 1 and 2
These automatically installing CDs put the alphabets, phrases, and clip art from Creating Keepsakes' Creative Lettering column at your fingertips, with 15 full-color fonts each (Orem, UT: Creating Keepsakes, 1999).
www.creatingkeepsakes.com
888/247-5282

The Color Printer Idea Book by Kay Hall
Instructions for using your color printer to make many craft projects, from notepads and bookmarks to clocks and calendars (San Francisco, CA: No Starch Press, 1997).
800/420-7249
415/863-9900

Home Book of Picture Framing, 2nd ed. by Kenn Oberrecht
Encyclopedic reference including all aspects of mounting, matting, and framing artwork (Mechanicsburg, PA: Stackpole Books, 1998).
800/732-3669
717/796-0411

PCStitch 5.0 by M & R Technologies, Inc.
Excellent software for cross-stitch pattern design (Dayton, OH: M & R Technologies).
800/800-8517

Quilting Your Memories by Sandy Bonsib
Making quilts with photo transfers; also includes an illustrated chapter devoted to using children's art in quilts (Bothell, WA: Martingale & Company, 1999).
800/426-3126

S.O.S. Saving Our Scrapbooks: Your Preservation Guide by Jeanne English and Al Thelin.
Special issue of *Creating Keepsakes* scrapbook magazine (Orem, UT: Creating Keepsakes, 1999).
888/247-5282

Step-By-Step Frame It Yourself by the editors of Creative Publishing International
A practical, easy-to-use guide full of useful matting and framing tips (Minnetonka, MN: Creative Publishing International 1999).
800/328-3895

Index

Abstract art
 as background paper,
 45, **45**
 design possibilities of, 60
 frames and, 9
 professional framing
 of, 21
 sizing of, 12
accordion books, 31, **31**
acid-free materials
 cardboard backing, 6
 cardstock, 11
 for storing art, 28
 in copying art, 29
 in professional framing,
 6, 20
 in scrapbooks, 29
 low-pH tissue, 11
 mats, 6, 10, 11
 paper, 11, 68
 postcard labels, 80
 refrigerator frames, 52
 wood frames, 6
acrylic clear finish for back
 of frame, 6
adhesives, 29, 50
announcements, 78, **78**
aprons, 66, **66**
archival-quality materials, 20
art
 see also abstract art;
 translucent art
 preserving, 6-7, 28-29,
 48, 68
 when to copy, 29, 48,
 68-69
art gallery frames
 stamps, 27, **26-27**
 Wallies, 26, **26**
artist portfolios, 8, **8**

Baby T-shirts, 65, **65**
background paper

 see also papers
 abstract art as, 45, **45**
 black, 34, **34**
backgrounds
 in photographing art,
 68-69
bookmarks, 69, 87, **87**
bulldog clip, 54

Calendars, 88, **88**
camera, "point-and-shoot,"
 33, 74
"canvas" paper, 9
captions, 22, **22**
cardboard backing, 6, 11
cards
 announcements, 78, **78**
 color photocopies of art
 and, 76, **76**
 from color printers,
 77, **77**
 gift tags, 81, **81**, 82, **82**,
 83, **83**
 invitations, 79, **79**
 made from scratch, 68
 messages in, 72, **72**
 photo frame, 73, **73**
 place, 55, **55**
 postcards, 80, **80**
 premade, 68, 71, **71**,
 73, **73**
 scrapbook techniques
 and, 70
 sets of, 74, **74**
 textured, 75, **75**
cardstock
 see also cards
 as backing, 50, 55, **55**
 custom die cuts and,
 43, **43**
 framing with, 53, **53**,
 58, **58**

 matting art with, 13, **13**,
 44, **44**, 71, **71**
 mounting art on, 11, **11**,
 12, **12**, 13, **13**
 paper-pieced cutouts
 from, 42, **42**
celebration gift tags, 83, **83**
checkbook covers, 49, **49**
Christmas gift tags, 81, **81**
cinnamon stick frame,
 19, **19**
clipboard frames, 17, **17**
clips and hooks for refriger-
 ators, 54, **54**
clocks, 61, **61**
clothespin displays, 23, **23**
clothing, 64, **64**, 65, **65**,
 66, **66**
collages, 16, **16**
 refrigerator, 52, **52**
color copiers
 cards, gift tags, and
 invitations and, 69
 for enlarging or
 reducing art, 9, 45,
 48, 50, 56, 74
 long-lasting copies
 from, 29
 transfer paper and, 49,
 65, 66
 true color and, 48
color printers
 "canvas" paper and, 9
 for enlarging art, 45
 instability of copies
 from, 29
 personalized greeting
 cards and, 77, **77**
 transfer papers and, 49
computer mouse pad,
 59, **59**
computer scanners, 29
 for greeting cards and
 envelopes, 69

to reduce or enlarge art, 45, 48
copying art, 29, 48, 68-69
corrugated paper cards, 75, **75**
cotton paper, 68
craft foam, 53, **53**
craft stick frames, 18, **18**
creative lettering
 in card making, 70, **70**
customized invitations, 79, **79**
cutout enhancements
 made from children's art, 41, **41**, 42, **42**, 43, **43**

Deacidification spray, 28, 29
decoupage, 56, **56**, 57, **57**
desktop items
 as gifts, 60, **60**
 frames, 12, **12**
die cuts, 10, 17, 54
 from children's art, 41, **41**, 42, **42**, 43, **43**
displaying basics, 7
dowel display, 25, **25**

Easter gift tags, 81, **81**

Fabric
 ironing images on, 49, 64, 65, 66, 67
 mouse pads made from, 59
 used as background in photography, 68
foam core
 cutouts from, 54, **54**
 mounting art on, 13, **13**, 14, **14**, 62
frame cards, 73, **73**
frames
 art gallery, 26, **26-27**, 27
 cardstock, 53, **53**, 58, **58**
 cards with, 73, **73**
 cinnamon stick, 19, **19**

clipboard, 17, **17**
craft stick, 18, **18**
foam core, 13, **13**, 14, **14**
for desktops, 12, **12**
from unusual objects, 19, **19**
home-made, 17, **17**, 18, **18**, 19, **19**
hung on a dowel, 25, **25**
magnetized, 51, **51**, 53, **53**
mat boards as, 6, 10, **10**, 11, **11**
metal, 6, 11
patterned paper, 14, **14**, 45, **45**, 53, **53**
Plexiglas, 11, **11**
professional, 6, 20, **20**, 21, **21**, 22, **22**
refrigerator, 51, **51**, 53, **53**
scrapbooking papers as, 32
stamped, **26-27**, 27
store-bought, 9, **9**, 12, **12**, 20, **20**, 21, 22, 25, **25**
twig, 19, **19**
wallpaper cutout, 26, **26**
wood, 6, 11
framing basics, 6-7

Games
 memory and spelling, 62, **62**
gift tags
 celebration, 83, **83**
 Christmas and Easter, 81, **81**
 multiple copies of art for, 69
 other holiday, 82, **82**
gift-wrapping paper, 69, 84, **84**
glass
 UV-filtering, 7, 20

Handwriting
 as art, 46, **46**

holiday gift tags, 69, 81, **81**, 82, **82**
hooks and clips for refrigerators, 54

Inkjet printers
 "canvas" paper and, 9
 instability of copies from, 29
 transfer papers and, 49
invitations, 79, **79**
iron-on transfers, 49, 64, 65, 66, 67

Jigsaw puzzle, 63, **63**

Key chains, 58, **58**

Lamination, 29
lignin, 6

Magnetic sheeting, self-adhesive, 50, 54
magnets, refrigerator
 big frames, 53, **53**
 collages, 52, **52**
 hooks and clips, 54, **54**
 little frames, 51, **51**
 simple, 50, **50**
mat boards
 acid-free, 6
 as frames, 10, **10**, 11, **11**
 cardstock as, 13, 44, **44**, 71, **71**
 to accent or soften, 6, 75
 with Plexiglas frames, 11, **11**
 with three-dimensional art, 6
matting basics, 6
McCrary, Kim, 36
memo pads, 86, **86**
memory game, 62, **62**
metal frames, 6, 11
metal rulers, 13

mini scrapbooks, 30, **30**
mobiles, 16, **16**
mounting art
 on cardstock, 11, 12
 on foam core, 13, **13**, 14,
 14, 62
mouse pads, 59, **59**
mugs, **49**

Napkin rings, 55, **55**
notes
 attached to back of art,
 22, **22**
 highlighted in scrap-
 books, 47, **47**

Papers
 acid-free, 11, 68
 "canvas," 9
 corrugated, 75, **75**
 magnetic-backed, 50
 100% cotton, 68
 patterned, 13, **13**, 14, **14,**
 45, **45**, 53, **53**
 scrapbook, 17, 32, 68
 transfer, 49, 64, 65,
 66, 67
 wrapping, 69, 84, **84**
patterned paper
 framing art with, 45, **45,**
 53, **53**
 mounting art on, 13, **13,**
 14, **14**
pencil holders, 60, **60**
permanent-frame gallery,
 26, **26-27,** 27
permanent ink, 29
photo frame cards, 73, **73**
photography
 for use on cards, 70,
 71, 73, 74, 75, 80,
 81, 82, 83
 how to photograph art,
 68-69, 74
 of artist at work, 33, **33,**
 34, **34**
 of work in progress,
 33, **33**

when to use, 29, 48
place cards, 55, **55**
plates, 57, **57**
Plexiglas
 box frames, 11, **11**
 UV-filtering, 7
"point-and-shoot" camera,
 33, 74
polypropylene lamination,
 29
portfolios, artist, 8, **8**
postcard labels
 self-adhesive, 80
postcards, 80, **80**
powder-toner copiers
 long-lasting copies
 from, 29
 transfer papers and, 49
preserving art, 6-7, 28-29,
 48, 68
printers, inkjet, 9, 29, 49
professional framing, 20,
 20, 21, **21,** 22, **22**
punch art, 10

Quilts, 67, **67**

Refrigerators
 big frames for, 53, **53**
 collages for, 52, **52**
 hooks and clips for,
 54, **54**
 little frames for, 51, **51**
 simple magnets, 50, **50**
return address labels, 69
rotation wheel, 40, **40**

School-year spreads in
 scrapbooks, 36, **36**
scrapbook papers, 17,
 32, 68
scrapbooking
 card making with tech-
 niques of, 70
 tips for, 29
scrapbooks
 accordion, 31, **31**

art as background paper
 in, 45, **45**
cutout enhancements for,
 41, **41,** 42, **42,** 43, **43**
documenting the artist at
 work in, 33, **33,** 34,
 34, 35, **35**
framing art for, 32, **32**
handwriting as art in,
 46, **46**
materials for, 29
mini, 30, **30**
notes highlighted in,
 47, **47**
profiling the artist in,
 35, **35**
recording variations in,
 39, **39**
rotating wheel in, 40, **40**
school-year highlights in,
 36, **36**
showcasing art in, 37, **37,**
 38, **38**
special interests reflected
 in, 44, **44**
theme, 30, **30**
three-dimensional art in,
 38, **38**
scribbles, 21
sets of cards, 74, **74**
sheet protectors
 display made from,
 15, **15**
 frames made from,
 53, **53**
shellac, 6
spelling game, 62
stamped frames, **26-27,** 27
stationery, 85, **85**
store-bought frames, 9, **9,**
 12, **12,** 20, **20,** 21, 22,
 25, **25**
stuffed animal chain, 24, **24**
sweatshirts, 64, **64**

Table settings, 55, **55**
textured cards, 75, **75**
theme scrapbooks, 30, **30**
three-dimensional art

displayed on refrigerators, 54
multiple mats and, 6
showcasing in scrapbooks, 38, **38**
three-dimensional art galleries, 26
transfer papers, 49, 64, 65, 66, 67
translucent art, 15, 24, **24**
trays, 56, **56**
T-shirts, baby, 65, **65**
twig frame, 19, **19**
twine-and-clothespin display, 23, **23**

Urethane, 6
UV-filtering glass, 7, 20

Variations
recorded in scrapbooks, 39, **39**
Velcro, 14
vellum, 45, **45**

Wall hangings, **7, 10**
cinnamon stick frames, 19, **19**
clipboard frames, 17, **17**
craft stick frames, 18, **18**
dowel display, 25, **25**
mobiles, 16, **16**
quilts, 67, **67**
sheet protector display, 15, **15**
stuffed animal chain, 24, **24**

three-tier, 14, **14**
twig frames, 19, **19**
twine-and-clothespin display, 23, **23**
wallpaper cutout frames, 26, **26**
wood frames, 11
acid-free, 6
words framed, 22, **22**
wrapping paper, 69, 84, **84**

Xyron machines
adhesives and lamination and, 29
magnetic backing and, 50